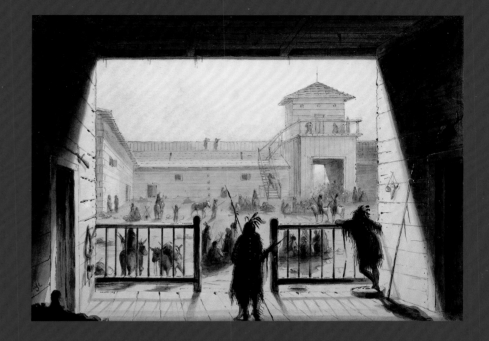

AFTER LEWIS & CLARK
The Forces of Change, 1806–1871

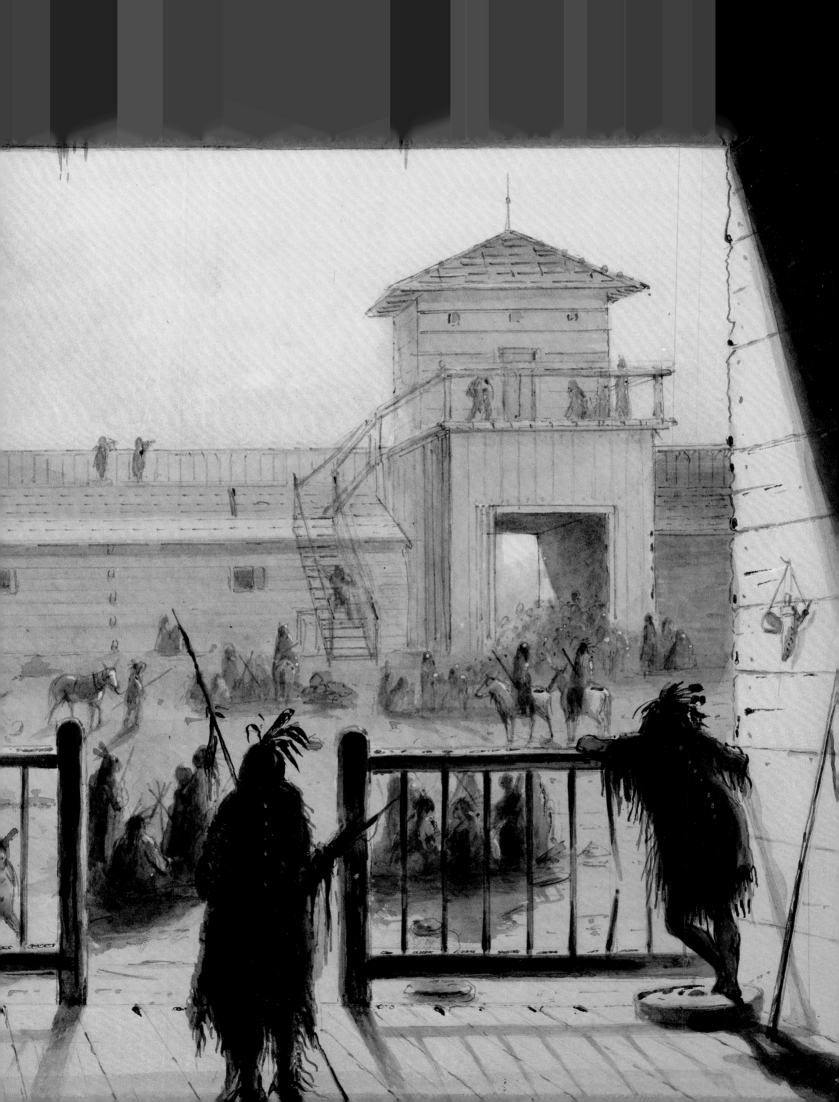

AFTER LEWIS & CLARK

The Forces of Change, 1806–1871

GARY ALLEN HOOD

Gilcrease Museum, Tulsa, Oklahoma

This publication is dedicated to the memory of
Sarah Jo Erwin
1952–2005
Collections Manager and Curator of Archival Collections
Gilcrease Museum
The people she touched during her years at Gilcrease
will remember her not only for her dedication as a curator,
but also for the warmth and humor she shared.

Published in conjunction with the exhibition
After Lewis & Clark: The Forces of Change, 1806–1871,
January 14–April 9, 2006.

Publication of *After Lewis & Clark* is partially underwritten
by The Ralph and Frances McGill Foundation and
The Trust Company of Oklahoma.

Copyright © 2006 by the Thomas Gilcrease Museum Association

The paper in this book meets the guidelines for permanence and durability
of the Committee on Production Guidelines for Book Longevity of the
Council on Library Resources, Inc.

Library of Congress Control Number: 2005937095
ISBN: 0-9725657-5-2 (hardcover)
ISBN-13: 978-0-8061-9959-7
ISBN-10: 0-8061-9959-8

Front cover: Alfred Jacob Miller, *Fort Laramie,* 1851 (detail; pl. 29)
Back cover: Emanuel Leutze, *Westward the Course of Empire Takes Its Way,*
c. 1861 (detail; pl. 55)
Front endsheets, recto; back endsheets, verso: George W. Boynton, *United States,*
c. 1850 (map 160, MC-7)
Front endsheets, verso; back endsheets, recto: After Samuel Seymour, "View
of the Rocky Mountains on the Platte 50 miles from their Base" (detail; pl. 2)
Frontispiece: Alfred Jacob Miller, *Interior of Fort Laramie,* c. 1837 (detail; pl. 30)
Pages 8–9: Carl Wimar, *Indian Encampment on the Big Bend of the Missouri
River,* 1860 (detail; pl. 23)
Pages 88–89: Alfred Jacob Miller, *Indian Procession in Honor of Captain
W. D. Stewart near the Rocky Mountains* (detail; pl. 36)

Dimensions of works are cited with height preceding width.

Edited by Paula Brisco
Proofread by Barbara McGill
Photography by Shane Culpepper
Designed by John Hubbard
Color separations by iocolor, Seattle
Produced by Marquand Books, Inc., Seattle
 www.marquand.com
Printed and bound by CS Graphics Pte., Ltd., Singapore

CONTENTS

FROM 1804 TO 1806, MERIWETHER LEWIS AND WILLIAM CLARK JOURNEYED through the newly acquired expanse of America known as the Louisiana Purchase. They encountered lands, rivers, wilderness, and peoples new to Americans of the East. The news of their exploration generated keen interest in the young nation.

Their journey was followed by those of other explorers who traveled throughout the West, from the Mississippi River to the Pacific Ocean and from the Canada of Britain to Spanish Mexico. The artists who accompanied these explorers encountered unexpected and unique subjects and gave birth to American western art. Many of the paintings they created were of a different nature from those that had been made earlier. European-inspired subjects were replaced with new American portraits and with landscapes peopled with noble Native Americans, rugged mountain men, and courageous explorers. Exploration of other regions of the West continued during the following decades, and by 1871 a new generation of artists had developed visions of grandeur and sublime scenes and were creating powerful pictorial documents of America.

The nineteenth-century art collected by Thomas Gilcrease (1890–1962) enhances understanding of that century. From the time of his first purchase in 1922 until his death in 1962, Gilcrease formed his collection with the recognition that works of art are connected to the era in which they were made, and that each work documents both history and art. At its inception the Gilcrease Museum was named the Thomas Gilcrease Institute of American History and Art in honor of this duality—art as history and history as art. Gilcrease deeded the collection to the City of Tulsa in 1955. The original museum building and grounds were given by the Gilcrease Foundation in 1958. The collection encompasses some of the earliest American

PREFACE AND ACKNOWLEDGMENTS

documents and books, masterworks from the colonial and federalist periods, and the classic, memorable, and enduring art of the American West.

The Gilcrease Museum is pleased to present this important selection from its collection to highlight examples of the changes that occurred in American art during the sixty-five years after Lewis and Clark completed their courageous journey. These works of art and Gary Hood's accompanying essay give us a glimpse of the people, places, and events that the artists of the early American West captured on paper and canvas, pictures that provided the world with a new perspective of America. The works allow us to see, through these artists' nineteenth-century eyes, the images that they encountered and interpreted, placing their paintings, drawings, and prints within an aesthetic as well as historic context. Through their experiences, we develop a deeper understanding of the West and its history. The impact of their work transcends time and—as with all great collections of art—continues to offer fresh insights today.

To develop an exhibition of this scope required the involvement of many members of the Gilcrease Museum staff, and I thank them for their efforts. The topic and main title of this exhibition were conceived by collections manager Sarah Erwin. The project has been overseen by senior curator Gary Hood with guidance from the executive director. Gary has written the insightful and informative essay. Special thanks go to our friend B. Byron Price, director of the Charles M. Russell Center for the Study of the American West, for his outstanding introduction to this publication. We also appreciate the work of Marquand Books in the design and production of the book and the guidance of the University of Oklahoma Press as distributor for the softcover edition.

The printing of the catalogue was partially underwritten by a very generous contribution from The Ralph and Frances McGill Foundation and The Trust Company of Oklahoma. We sincerely appreciate their continuing support of special exhibitions at the Gilcrease Museum. We are extremely grateful to the Thomas Gilcrease Museum Association for their generous support of the project and the City of Tulsa for sharing this important collection with the public.

The Gilcrease is also honored to have the Art Museum of South Texas in Corpus Christi as a second venue for this exhibition. The museum is a component of the South Texas Institute for the Arts and affiliated with Texas A&M University–Corpus Christi. After the exhibition closes in Tulsa, it travels to the Art Museum of South Texas and serves as the first major show for its expanded museum complex. We expect to share the exhibition with other museums in the future.

I trust that you will find *After Lewis and Clark: The Forces of Change, 1806–1871* to be educationally enlightening and visually compelling.

Joseph B. Schenk
Executive Director
Gilcrease Museum

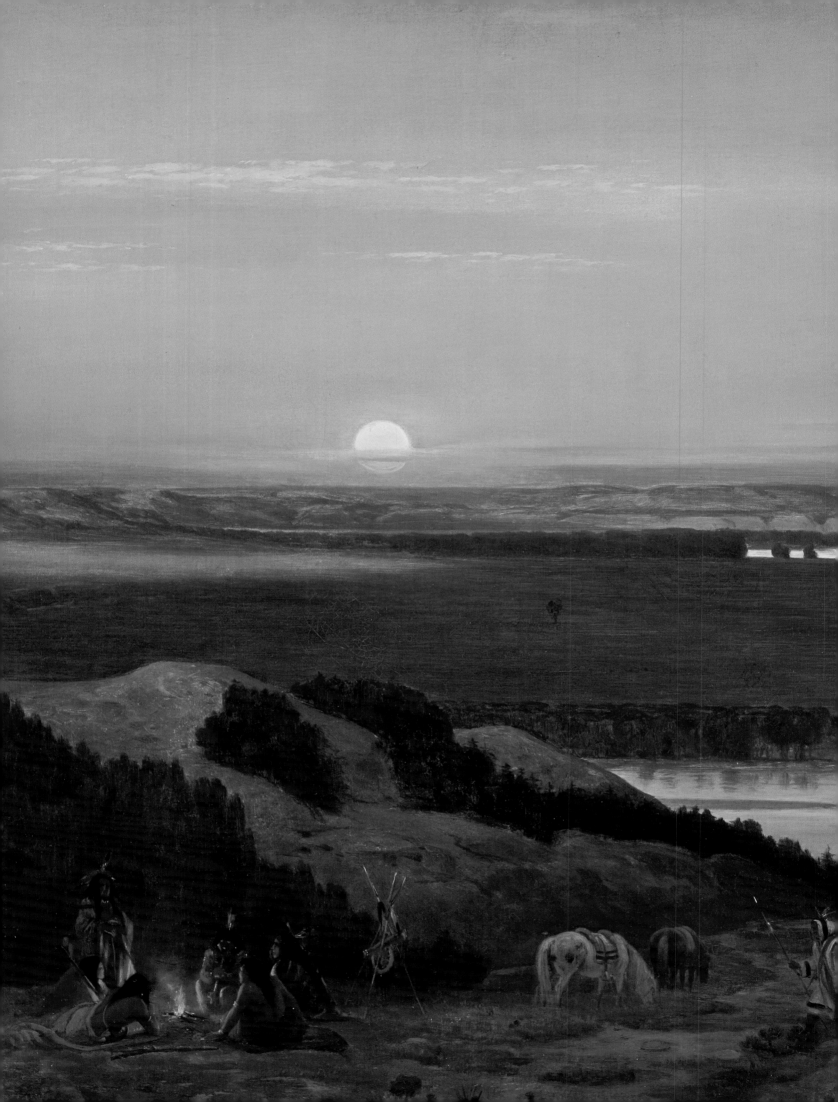

THE SIX-AND-A-HALF DECADES BETWEEN THE RETURN OF THE LEWIS AND CLARK expedition from its historic journey to the Pacific in 1806 and Thomas Moran's first trip to the West (to Yellowstone) in 1871 were a period of artistic as well as physical exploration of the American West. Artists of the era—some of them homegrown, others with European training—not only gave Americans their first glimpses of the intriguing lands and peoples that lay beyond the Mississippi River but also created images that helped define the nation and advance the nascent ideas of Jacksonian democracy and manifest destiny.

Before the completion of the transcontinental railroad in 1869, journeys westward were arduous, expensive, and often dangerous. The relatively few artists who attempted the trek depended upon government bureaucrats, Indian traders, or wealthy patrons for provisions, protection, and employment. In 1820 Samuel Seymour and Titian Ramsay Peale, the first American artists to enter the region, crossed the Great Plains to the Rocky Mountains with a government-sponsored scientific expedition commanded by Major Stephen H. Long. Although only a few of the paintings and sketches inspired by the trip ever reached the public eye, they foreshadowed the critical role that federal patronage would play in the early artistic documentation of the West.

Not long after Seymour and Peale returned home from their landmark foray, U.S. Indian Commissioner Thomas L. McKenney began hiring artists to render the portraits of prominent tribesmen visiting the East for treaty talks with government officials. Like many Americans of his day, McKenney believed that the indigenous tribes of the West were doomed to extinction by the imperatives of progress and the inevitable advance of "civilization."

This belief also motivated George Catlin, an energetic and ambitious young painter, who journeyed thousands of miles, produced hundreds of works, and

INTRODUCTION

created a stunning visual record of Indian tribes from the Upper Missouri River to the Southern Plains between 1830 and 1836. In the years that followed, Catlin's traveling "Indian Gallery" introduced countless Americans and Europeans to the exotic Indian cultures of the American West.

Scientific inquiry, the desire for adventure, and the acquisition of new lands drew still other artists westward before the Civil War. During the 1830s painters in the service of wealthy Europeans romanticized the western fur trade and rendered precise ethnographic depictions of Indian life on the Northern Plains for exhibition and publication at home and abroad. A few years later an elderly John J. Audubon arrived in the region intent on producing a study of American mammals to rival his previous work on birds.

The opening of the Oregon Trail as an emigrant thoroughfare in the early 1840s, and the territorial gains secured in the war with Mexico not long after, prompted a new round of government-sponsored exploration known as the Great Reconnaissance. The accompanying artistic activity suggested feasible railroad routes, illuminated the economic opportunities that awaited new settlers, and hinted at the hardships and sacrifices necessary to lay claim to the continent.

On the eve of the Civil War, sublime images of tall mountains, deep canyons, and broad vistas sprang from the brush of Albert Bierstadt and Thomas Moran to remind Americans, preoccupied as they were with slavery and sectional conflict, of the West's divinely ordained grandeur and promise. After the war, such images helped bind the nation's wounds and sent a new generation of Americans westering.

B. Byron Price
Director
Charles M. Russell Center for the Study of the American West
University of Oklahoma

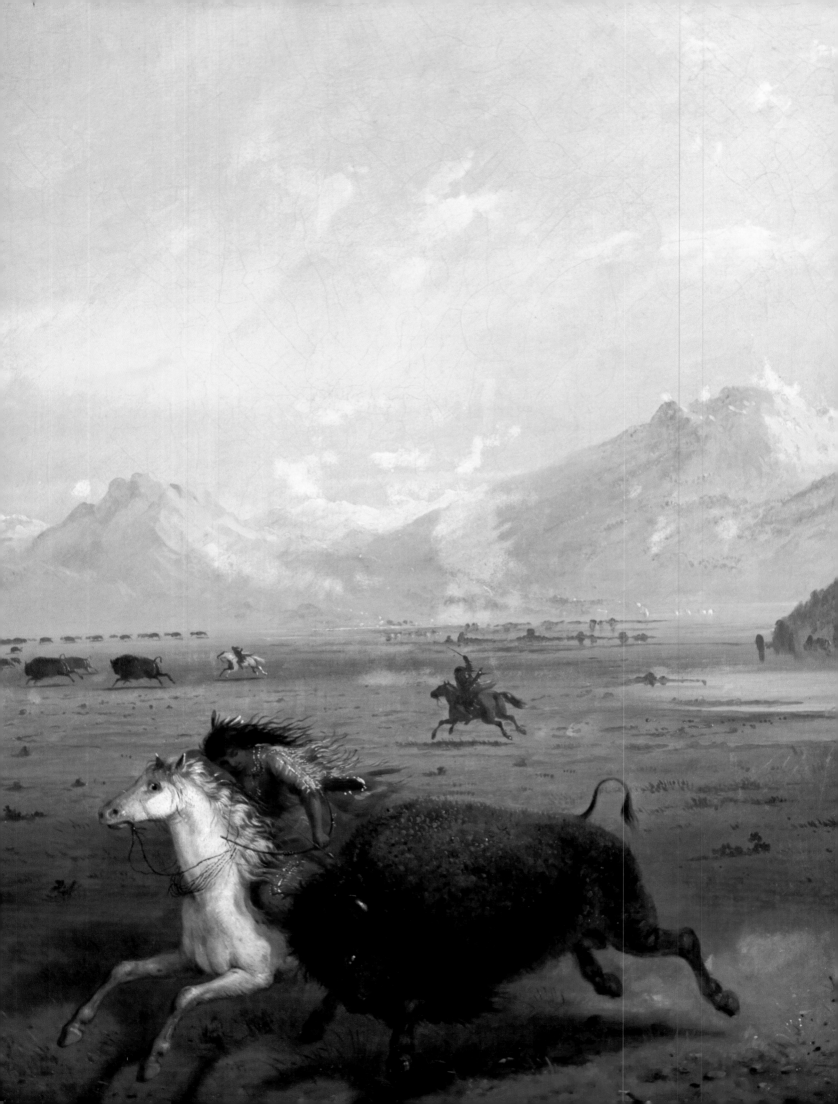

As the American West changed in the nineteenth century, what was represented about it also changed. Western art began predominantly as portrait painting, then evolved into scenes that spoke of western life and the character of the West, and then gravitated toward grandiose landscapes. Reflecting the explorations that came after Lewis and Clark's great adventure, the artistic heritage of the nineteenth century marks the people, events, and places—the forces of change—that characterized the passage of an era, and the artists' works speak of the choices that were made to create the history as it is now.

As America expanded its western horizons, artists journeyed with its explorers and settlers. The eastern public hungered for news and images of the West, and publishers sought truthful stories and pictures of the new discoveries. Adventuresome artists journeyed to the West to capture its beauty and its dangers; they went to satisfy their own curiosity as well as to satiate the East Coast readers of books, journals, magazines, and newspapers. The same artists returned to their studios to paint finished scenes, make prints, sell portfolios and paintings, and exhibit their work to throngs of the curious. Collectors and governments purchased images of the West for their museums, archives, and libraries.

Historically, art mirrors the world in which it was created. It pictures historical events, personages, aesthetics, and spiritual awakenings. *Narrative, reportage, illustration,* and *documentary* are words often applied to art that visually describes a person, event, or scene connected to the time it pictures. Western art has been described in such terms. Today the art of the nineteenth century is valued for its ability to both aesthetically and historically describe the time in which it was created.

THE FORCES OF CHANGE, 1806–1871

OPPOSITE:
Alfred Jacob Miller, *Buffalo Hunt,* 1840 (detail, pl. 21)

From 1804 to 1806, Meriwether Lewis (1774–1809) and William Clark (1770–1838) led the first scientific and ethnographic exploration of the interior of the West. Their Corps of Discovery was the first team to travel the entire course of the Missouri River. But it was not the first exploration of interior America west of the Mississippi.

From 1712 to 1724, French explorers made attempts to explore up the Missouri River, going as far as the mouth of the Platte River. The plains of modern-day Kansas were the destinations of other French expeditions. During the same period, the Spanish explored the western high plains (now part of Colorado) to the confluence of the North and South Platte rivers in today's west central Nebraska.

Between 1738 and 1743, the French explored south from Canada to the Mandan villages along the Missouri River in central North Dakota. From 1739 to 1740, the French also explored up the Missouri River to make first contact with Pawnee Indians near the northeast corner of Nebraska before they turned south to the Platte River, headed southwest to Santa Fe, and returned east along the Canadian, Arkansas, and Mississippi rivers to New Orleans. From 1774 to 1776, the Spanish explored a circuit from Santa Fe northward and west to the body of water now known as Utah Lake, and back south through Hopi and Navajo country (Arizona) to Zuni Pueblo (New Mexico) before returning to Santa Fe.[1]

Artists did not accompany these first explorations. Although French and Spanish explorers mapped various eastern and southern parts of what was then known as Louisiana Territory (which would later become the Louisiana Purchase), the resulting maps were not shared with the fledgling United States government, as each country sought to claim the region for itself. The Louisiana Territory was in French hands until 1762, when it was ceded to the Spanish to prevent it from falling into British hands at the ending of the French and Indian War by the Treaty of Paris of 1763, coincidentally signed the same year that the "gateway to the West," Saint Louis, was founded. Twenty years later, the Treaty of Paris of 1783 officially ended the Revolutionary War and fixed the boundaries of the United States westward to the Mississippi River, south to Spanish Florida, and north to British Canada. In 1800 the Spanish, by treaty, returned the Louisiana Territory to the French.

Thomas Jefferson, third president of the United States (1801–09), was passionate about expanding the country in physical size as well as international influence, and he sought that purpose through both treaty and purchase. The U.S. government ordered most of the explorations of the West, starting with Lewis and Clark's journey, with the thought of expansion and the intent to eventually open the vast region to settlement.

In 1803, at the direction of Thomas Jefferson, U.S. envoys Robert Livingston and James Monroe arrived in France to negotiate for the purchase of New Orleans, southern Louisiana, and west Florida. Livingston and Monroe were surprised and pleased to learn that Napoleon was interested in selling the entire Louisiana Territory. They reached agreement with Napoleon's government on April 29, 1803, eighteen days after negotiations began, acquiring the territory for $15 million (equivalent to $193 million today). With the addition of 820,000 square miles (for three cents per acre), the purchase doubled the size of the United States as it had been recorded

during the 1783 Treaty of Paris. With overwhelming public support, the purchase was ratified by Congress on October 20, 1803. The president's thoughts were to expand the nation from sea to sea, and Congress approved $2,500 ($32,000 today) to fund an exploration that Jefferson had designed even before the purchase. He planned the exploration with Meriwether Lewis, who was his secretary at the time; Lewis asked William Clark to be his cocaptain, and they organized a "Corps of Discovery" for the exploration. Although the Pacific Northwest was not included in the purchase, Jefferson ordered his exploring unit to travel up the Missouri River through the Louisiana Purchase and into the Oregon Country all the way to the Pacific Ocean, in hopes of finding a water route across the continent that was long thought to exist. (Lewis and Clark's journey proved that supposition to be fiction.)

The expedition departed on the epic journey from Saint Louis, which had been founded in 1763 as a business and fur-trading center. As a trading post it was, at the time, the westernmost supply depot for mountain men, fur traders, and explorers and thus became known as the Gateway to the West. The earliest population figures for Saint Louis are from the 1810 census, when 1,400 people were counted as residents. By 1840 some 16,000 were in residence, and as the United States expanded westward, the population rose dramatically to more than 160,000 in 1860.

Meriwether Lewis and William Clark carefully selected forty-some military veterans to accompany them on the epic journey that shaped the future of the United States. They began their journey up the Missouri River on May 14, 1804. They gathered several other travelers along the way, including Sacajawea and her husband, Toussaint Charbonneau. Sacajawea was a Shoshone who had been captured by the Hidatsas and traded to the Mandans, who sold her to Charbonneau, a French Canadian trapper. Lewis and Clark hired Charbonneau as their interpreter after they met him at the Mandan village during the winter of 1804–05, and Sacajawea's son, Jean Baptiste Charbonneau (whom Clark nicknamed "Pompey"), was born on February 11, 1805. The pages of Lewis's journal for April 7, 1805, record the names of the party of thirty-four departing Fort Mandan for the Pacific; others returned to Washington, D.C., with specimens. Among the group continuing west were Lewis and Clark; twenty-six soldiers; two interpreters; a guide; Captain Clark's servant, York; and Sacajawea and her son, who are identified simply as "an Indian Woman, wife to Charbono [sic] with a young child." However, in Clark's personal journal entry, dated "Fort Mandan April 7th 1805," he writes of "Shabonah [Charbonneau] and his *Indian Squar* [sic] to act as interpreter and interpretress for the Snake Indians—one Mandan & Shabonahs infant." Then he names *"Sah-kah-gar-we-a."*[2] Sacajawea's presence during the remainder of the expedition, and her talents as guide and interpreter, proved priceless.

Lewis and Clark chose the original members of their group for their talents as soldiers and explorers. William Clark served as the all-important mapmaker, and Meriwether Lewis was the scientist and naturalist. There was no trained artist among them, however, and when they encountered unique lands, animals, plants, and people, they were at a loss to picture them other than by written descriptions and a few rudimentary sketches.

From May 14, 1804, to September 23, 1806, the corps traversed a total of more than eight thousand miles up the Missouri River, across the Rocky Mountains, down the Columbia River to the shore of the Pacific Ocean, and back again. Despite the perils of the journey, only one life was lost, and that was through, it is thought, a burst appendix. The journey of the Corps of Discovery was a triumph of skill and extraordinary bravery. Afterward Lewis was appointed governor of the Upper Louisiana Territory, a position he held until his death in 1809. Clark later became the U.S. superintendent of Indian Affairs and governor of Missouri Territory, the name given to the Louisiana Purchase after the state of Louisiana was formed in 1812. Other states were later carved out of the territory, including Missouri (territory, 1812; statehood, 1821) and Arkansas (territory, 1819; statehood, 1836).

After Lewis and Clark, other explorers traveled the western half of the continent, and the trails they discovered opened it up for future settlement. In the 1810s two British fur-trading companies—Hudson's Bay Company and North West Company— blazed trails from Canada into the Rocky Mountains and the Northwest. John Jacob Astor and his Pacific Fur Company also made an American business claim to Oregon Country, the region from the northern California border to the southern tip of Alaska. Through the 1820s and 1830s, mountain men, trappers, and fur traders abounded throughout the Northwest and the Rocky Mountains. The trails they found eventually helped open the region to settlement.

Most of the earliest expeditions to the West followed the Missouri or North Platte rivers and were undertaken by mountain men and trappers and by commercial outfitters and buyers such as the American Fur Company. Yet while mountain men and the Corps of Discovery were making inroads to the West, Captain Zebulon Pike, under U.S. military orders, explored the upper Mississippi River in 1805 and 1806. Returning to Saint Louis, Pike received orders to travel to the central and southeastern Rocky Mountains (in what is now Colorado and New Mexico) before proceeding toward Santa Fe, where he was arrested by the Spanish occupiers as an American spy. He was taken back to U.S. territory (Louisiana) in 1807 by way of Chihuahua, Mexico. The account of his travels was published in 1810.[3]

Although the leaders failed to think of enlisting an artist for the Lewis and Clark journey or for Pike's expeditions, planners of later government explorations either hired or allowed artists to accompany their exploration and survey teams to visually record the scenes and adventures they encountered.

Titian Ramsay Peale (1799–1885) and Samuel Seymour (1875–c. 1823) were the first professional artists to join a western expedition. They accompanied the first serious exploration of the central Great Plains from 1819 to 1820. As "the first official painter for a western exploration," Seymour made 150 landscape views.[4] Using his sketches as memory aids, he made sixty paintings after his return to the East; some were published as engravings in the atlas of the account of the exploration, including "War Dance [Dog Dance] in the Interior of a Konza [Kansa] Lodge" (pl. 1), one of the first field drawings of a Plains Indian dance and the interior of a Plains lodge. In 1823 Seymour's "View of the Rocky Mountains on the Platte 50 miles from

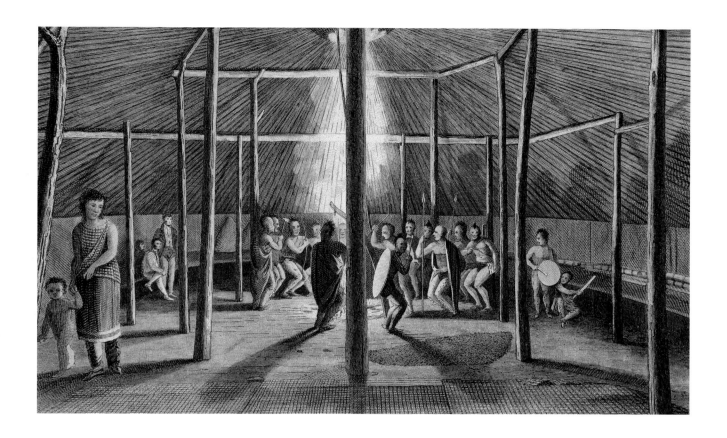

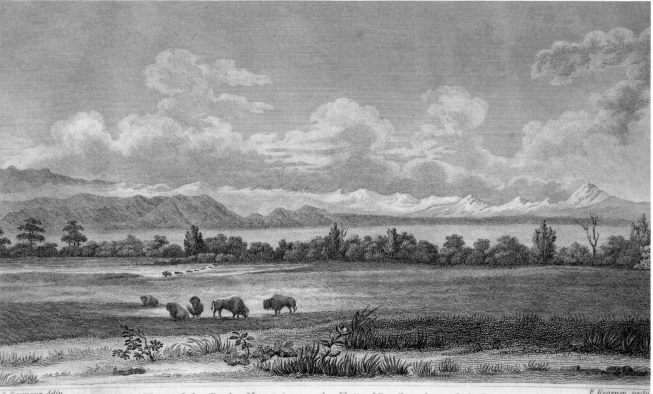

S. Seymour delin.

View of the Rocky Mountains on the Platte 50 miles from their Base.

F. Kearney sculp.

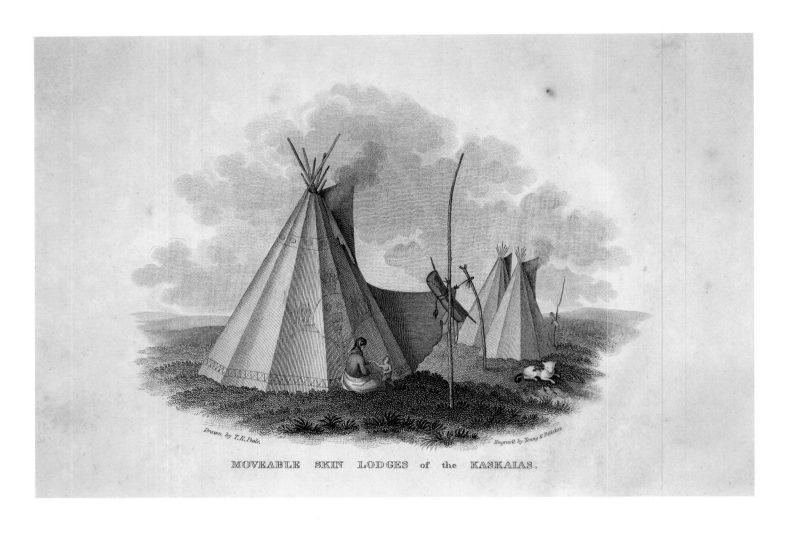

MOVEABLE SKIN LODGES of the KASKAIAS.

After TITIAN RAMSAY PEALE

3 "Moveable Skin Lodges of the Kaskaias"

1823, engraving, 6¾ × 8¾ in., in Edwin James,
*Account of an Expedition from Pittsburgh to the
Rocky Mountains . . . ,* atlas vol. (2426.228)

their Base" (pl. 2) became the first published "eyewitness" image of the mountain chain.[5] One image by Peale was also engraved and printed for inclusion in the atlas: "Moveable Skin Lodges of the Kaskaias" (pl. 3). The Kansa (Kaw) people were initially settled along the Kansas River, a tributary of the Missouri, but they were living in the central plains (of Kansas) when Seymour and Peale met them. Seymour had been born in England but came to the United States and was working as an artist in Philadelphia when he was selected for the expedition. A fellow Philadelphia artist, Peale (the youngest son of painter, museologist, and collector Charles Willson Peale) was the assistant naturalist on the expedition, and he is credited in the expedition report with having made one hundred twenty-two sketches.[6]

Unfortunately, the leader of the party, Major Stephen Long, claimed that the Great Plains were a "Great Desert" and identified the region as such on one of the two maps that accompanied the 1823 book by the expedition naturalist, Edwin James, about the Long expedition.[7] He wrote: "In regard to this extensive section of the country, I do not hesitate in giving my opinion, that it is almost wholly unfit for cultivation, and of course, uninhabitable by a people depending upon agriculture for subsistence."[8]

Long's description was neither refuted nor corrected until twenty years later, when the expansionist-minded military explorer John Charles Fremont wrote that the region was rich with lush grasses and arable soil. Fremont was a member of the U.S. Army's newly formed Corps of Topographical Engineers and was known as "the Pathfinder" due to his many western mapping explorations. With an eye toward eventual settlement of the region, he stated: "Everywhere the rose is met with and reminds us of cultivated gardens and civilization."[9]

Two of the greatest monuments of the West were not manmade but natural wonders: Yellowstone and Grand Canyon. Essentially unknown until artists began painting them, they were set aside as national parks in 1872 and 1908, respectively. Thomas Moran (1837–1926) was the first to memorialize Yellowstone and Grand Canyon through his paintings—in fact, the two subjects came to be forever intertwined with his name—and Congress created the park legislation after seeing Moran's first paintings of Yellowstone.

The testimonial to the dramatic changes that occurred in art of the American West can be seen in the landscapes of Thomas Moran. *The Glory of the Canyon* (pl. 4) is a tribute to the landscape of the West. The brilliance of the color and the impressionistic effect were uncommon to American painting of the time, and Moran's landscape inspirations had an impact on many artists who came after.

In 1871 Moran's breakthrough style marked the end of the first chapter of artists' portrayals of the American West. The chapter starts in the early nineteenth century with artists who created portraits of Indians and with artists who became explorers. Some were European-trained American artists and some were self- or family-taught. There were also artists who made paintings of the virgin western landscape, and others who depicted industrial development or made portrayals of scenes of war.

The second quarter of the 1800s was a wide-eyed age of expansionism. The 1840s were known as a period of "manifest destiny," a prescription for acquisition of land by the U.S. government from European and Indian nations. It was also an era of industrial expansion and of growth in artistic thought. The kind of painting that developed between 1825 and 1850 dominated the art of the West through the 1860s. The era of manifest destiny was a frontier for pioneers in the painting arts as well for explorers. Artist-explorers often developed their paintings of the West from their sketches when they returned to their eastern studios. Other painters of the West—those who rarely if ever traveled beyond the East—depended on newspaper or eyewitness accounts and illustrations in the journals and magazines of their day.

Easterners did not understand the cultures of the original inhabitants of the lands they bought or made treaty with in order to establish settlements. Artists were the first to give a face to these ancient cultures. Some said these native cultures never changed, but in reality their civilizations were constantly adapting throughout their history by making reasoned choices. For example, they were quick to adapt to the availability of the horse, to the use of glass beads for decoration in place of porcupine quills and metal in place of bone or rock, and to drawing on paper in place of painting on hides.

The artists who depicted the early American West created visual records of the passing of an era. Their images reached a great number of people, and their endurance as artists is attributed not only to their artistic abilities but also to their role as recorders and, to a degree, shapers of history. The early nineteenth-century empathy toward "noble" Native Americans had much to do with the images that were presented by artists such as Charles Bird King (1785–1862), George Catlin (1796–1872), Karl Bodmer (1809–1893), Carl Wimar (1828–1862), John Mix Stanley (1814–1872), and their artist compatriots of the early years as well as those of midcentury.

Charles Nahl (1818–1878) was an American artist of the middle nineteenth century. Born in Germany and descended from a line of German artists, he emigrated to the United States at age thirty. Three years later the artist/illustrator became an "argonaut"—the name attached to adventurers during the California gold rush days (1848–64) who traveled from the East by ship to San Francisco. Rather than go around Cape Horn at South America's southern tip (a voyage of at least five months), Nahl sailed to Panama, crossed the Isthmus, and continued by ship. In California, Nahl worked in a mine, but later he put his considerable artistic skills to work making illustrations for local publications and painting portraits of gold seekers. Settling in San Francisco in 1852, he opened a photography and art studio.[10]

Nahl painted *Treaty with the Shoshone Indians in 1866* (pl. 5) most likely under the aegis of Caleb Lyon, Idaho Territory's second governor and superintendent of Indian Affairs from 1864 to 1866.[11] The treaty was negotiated by Lyon on April 12, 1866, at Bruneau River in what is now southwestern Idaho, with the "Chiefs and Head Men of the Bands of Sho-sho-nees occupying & claiming certain lands south of the Sho-sho-nee River between Salmon Falls and the mouth of the Owyhee, and

THOMAS MORAN
4 *The Glory of the Canyon*
1875, oil on canvas, 52 × 38½ in.
(0126.2350)

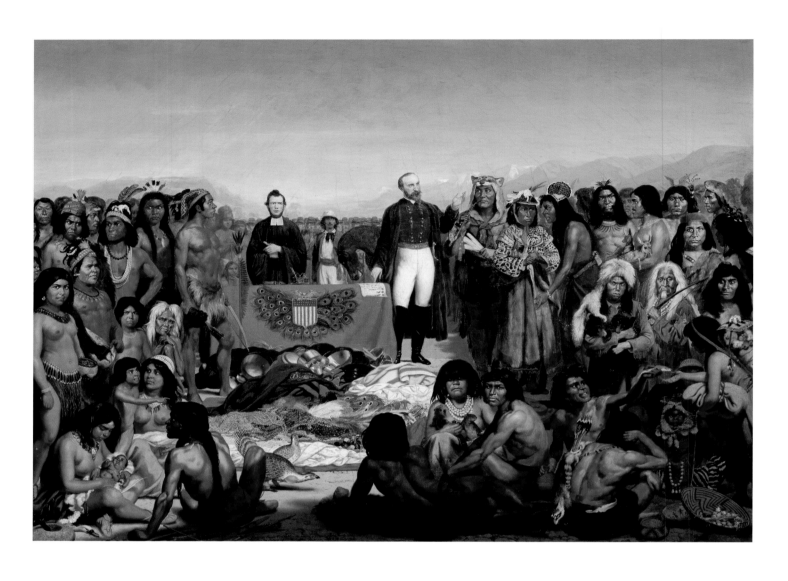

CHARLES C. NAHL
5 *Treaty with the Shoshone Indians in 1866*

Undated, oil on canvas, 27 × 37 in. (0136.1481)

extending south to the summits of the Goose Creek and Owyhee range of Mountains. / Article 1st The said tribes and bands of Indians hereby cede and relinquish and convey to the United States all their right, title, and interest in and to the following lands and country occupied by them / Article 2nd There is however reserved for the present use and occupation of the said tribes and bands the . . . tract of land . . . surveyed and marked out for their exclusive use"[12]

Caleb Lyon, two Shoshone chiefs, a subchief, and thirty-nine other tribal leaders signed the treaty. Also signing, as witnesses to the proceedings, were the U.S. Infantry Commander of the District of Boise; three U.S. Indian agents; S. E. McCandlys, the interpreter; and Hiram Hamilton, pastor of the Baptist Church. These final two appear near the center of the painting; metaphorically the pastor lends a divine authority to the proceedings. Lyon must have asked Nahl to place him in the center of the painting, thus lionizing his image as the supreme and final authority. It is likely that Charles Nahl never went to Idaho and never saw Shoshone Indians, and he appears to have used the Indians of California as models instead.

Idaho received territorial status in 1863 and became a state in 1890. Texas had become a state eighteen years earlier after annexation by the United States, but it was first an independent republic after its war with Mexico in 1836. In 1846, a year after Texas became a part of the Union, the Mexican War broke out.

With expansion on his mind, James K. Polk, president from 1845 to 1849, had first called for the acquisition from Mexico of both California and New Mexico by peaceful means. After his envoy failed to come to an agreement, the increased American military presence in a region (the southern tip of Texas) claimed by both Mexico and the United States incited Mexican troops to cross the Rio Grande on May 9, 1846. Four days later, Congress declared a state of war between the two nations.

By 1847 Americans were fighting south of the Rio Grande, and the Battle of Buena Vista was waged on February 23, 1847. General Zachary Taylor reported that the battle involved five thousand American soldiers against twenty thousand of the Mexican Army commanded by General Santa Ana. The Americans held the benefit of more and better artillery and repulsed Santa Ana's attack, resulting in American control of northeastern Mexico. James Walker (1819–1889) was a witness to the Mexican War, and his painting *The Battle of Buena Vista* [Mexico] (pl. 6), reveals the gallantry of the American soldiers against apparently overwhelming odds. Although outnumbered four to one, through brilliant strategy Zachary Taylor's forces held their ground. Taylor's report stated:

> The services of the light artillery [seen on the left], always conspicuous,
> were more than usually distinguished. Moving rapidly over the roughest
> ground, it was always in action at the right place and at the right time,
> and its well directed fire dealt destruction in the masses of the enemy. . . .
> [The U.S. infantry soldiers] were highly conspicuous for their gallantry and
> steadfastness, and sustained throughout the engagement the reputation
> of veteran troops. Brought into action against an immensely superior force,
> they maintained themselves for a long time unsupported and with heavy
> loss, and held an important part of the field until reinforced.[13]

Although Santa Ana retreated to defend Mexico City, his forces were depleted in successive battles. The 1851 hand-pulled and hand-colored lithograph of Carl Nebel's work, "General Scott's Entrance into Mexico" (pl. 7), shows the scene of September 14, 1847, as Winfield Scott, commanding general of the American army, leads his forces into the plaza of Mexico City. Scott made peace with the Mexican government, and it was confirmed by the treaty of Guadalupe Hidalgo on February 2, 1848. For $15 million ($297 million today) and the settling of all claims against their government, Mexico ceded what became California, Nevada, Utah, Arizona, New Mexico, western and southern Colorado, southwest Kansas, the panhandle of Oklahoma, and west Texas. The United States completed the contiguous states through the 1853 Gadsden Purchase (thirty thousand square miles for $10 million, about $222 million today) encompassing the area south of the Gila River (southern Arizona and extreme southwest New Mexico). The region was recognized as the best southern route for a railroad to the Pacific.

While America was engaging in the Mexican War, President Polk avoided war with Britain over the disputed Oregon Country, and Congress ratified the Oregon Treaty on June 15, 1846. The treaty fixed the United States/Canada boundary at the forty-ninth parallel, essentially dividing Oregon Country in half—the north going to Britain and the south to the United States (the two countries had held joint claim to the region since 1818).

JAMES WALKER
6 *The Battle of Buena Vista* [Mexico]

Undated, oil on canvas, 23½ × 38½ in.
(0126.1633)

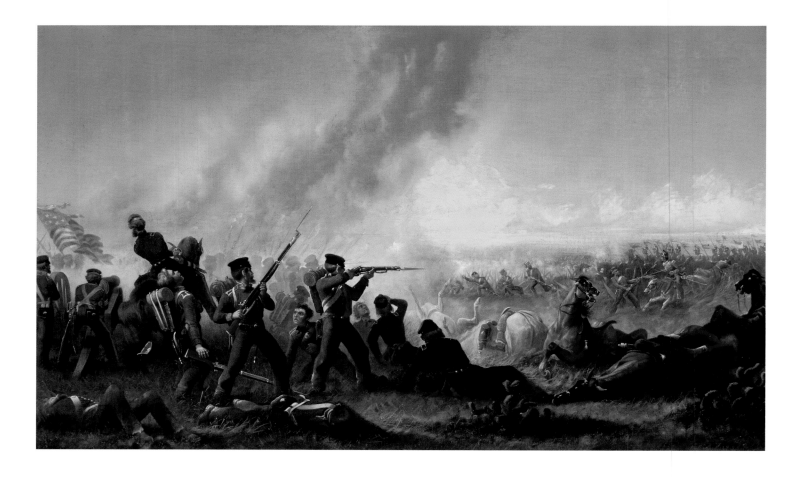

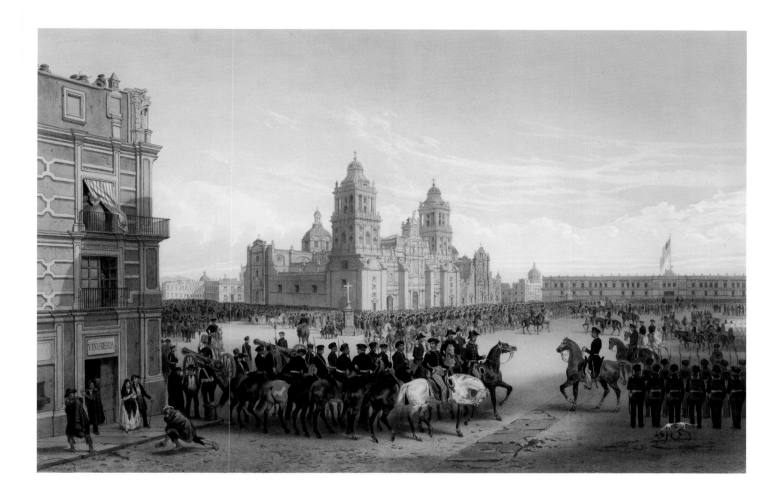

After CARL NEBEL
7 "General Scott's Entrance into Mexico"
Hand-colored lithograph, 11⅛ × 17 in., in George Wilkins Kendall, *The War between the United States and Mexico*, 1851 (2526.3008)

Earlier in the nineteenth century, as the Napoleonic Wars of 1803 to 1815 began in Europe, the American public's attention was turned toward building the new nation and expanding settlement west of the Appalachian Mountains. However, Napoleon's quest for a European empire brought about his sale of the Louisiana Territory in 1803. Suddenly the public's attention shifted to their desire for details about the new acquisition.

At that time American interest in the arts was in a youthful state. The first artworks to gain prominence in America were portraits. Possessing a likeness of a hero of the Revolution or of one's own family members was highly valued. Itinerant portrait painters traveled the land, making portraits for all who could afford their price, from large paintings to be hung on walls to miniature paintings that could be carried as keepsakes in purse or pocket. European-trained painters were among the early leaders in American portrait making. The first practical method of producing multiple original images inexpensively was through the use of a pantograph. A seventeenth-century German invention, the pantograph could be used to make larger or smaller images from a master drawing. The idea was adapted by Gilles-Louis Crétien in France during the latter part of the eighteenth century as an artist's aid for making portraits. It came to be known in America as the "physiognotrace." The outlining instrument was used with a pantograph to inscribe the features on a sheet of paper. It consisted of four jointed rods in the shape of a parallelogram that could copy a two-dimensional image to a larger or smaller scale. The physiognotrace only assisted with drawing the outlines, however;

the artist had to fill in the blanks by drawing or painting the details of eye, ear, mouth, cheek, hair, and clothing and shading inside the outlined profile.

One artist who exploited the physiognotrace was Charles Balthazar Julien Févret de Saint-Mémin (1770–1852). Formerly an officer in the palace guard of Louis XVI, Saint-Mémin was a refugee from the French Revolution who became an important portraitist during the federalist period. He arrived in the United States in 1793 and in 1796 turned to his youthful avocation of art to develop a career as a portraitist in both drawing and engraving. He worked in Baltimore, Philadelphia, and Washington, D.C., making profile portraits by utilizing a "wooden framed drawing device of a type invented by [Gilles-]Louis Chretien [*sic*] about 1787. With this physiognotrace, as the machine was known, he quickly traced an exact, life-size profile of his sitter on a large sheet of tinted paper. Then he finished the portrait in . . . crayon. / In this manner Saint-Mémin executed the earliest known portraits of Plains Indians. . . . [H]is portraits reveal fine draftsmanship in his modeling of the heads."[14]

During their return to Saint Louis down the Missouri River, Lewis and Clark stopped at a Mandan village to invite the Mandan chief Shahaka, his wife, Yellow Corn, and their son to accompany them back east. Lewis and Clark had met Shahaka in October 1804 during their outward journey and spent time with him during their encampment at Fort Mandan in the quarters they had built for the winter of 1804–05. The return of the cocaptains to Washington, D.C., in December 1806 "occasioned a great celebration," and on New Year's Day 1807, Shahaka (White Coyote), nicknamed the Big White, was among a visiting group of Indians (mostly Osages) in Washington who performed "several dances of character and the great Calumet Dance." In attendance at the ceremony was Sir Augustus John Foster, the British minister, who commissioned several portraits of the Indians. Included were the portraits that Saint-Mémin painted of *Mandan King* [Shahaka, Mandan Chief] (pl. 8) and *Mandan Queen* [Yellow Corn, Wife of Shahaka] (pl. 9) in 1807. Shahaka and his family returned to their Mandan village in 1809. It is thought that Lewis also commissioned portraits from Saint-Mémin, because he had intended on publishing his journals with illustrations. Unfortunately, "Lewis died [in 1809] before he could carry out his plans, and when his journals were finally published, they were not illustrated."[15] With the threat to his life abated during Napoleon's regime, Saint-Mémin returned to France in 1810.

In the early 1820s, Michigan Territory governor Lewis Cass arranged for the government to commission James Otto Lewis (1799–1858) to paint Indian portraits. The Detroit artist went with Thomas McKenney, superintendent of the Bureau of Indian Affairs, to four Indian treaty councils between 1825 and 1827 and subsequently published his *Aboriginal Port Folio,* a series of some eighty hand-colored lithograph portraits that resulted from his "pencilling by the way," as exemplified by the image of Kee-o-kuck (pl. 10).[16] Charles Bird King paid Lewis tribute by copying some of his work for Thomas McKenney's Indian Gallery, later to be used as sources for the lithographs in McKenney and James Hall's *History of the Indian Tribes of North America* published between 1837 and 1844. Recognizing that some might think his

CHARLES BALTHAZAR JULIEN
FÉVRET DE SAINT-MÉMIN

8 *Mandan King* [Shahaka, Mandan Chief]

1807, watercolor on paper, 6¾ × 6 in.
(0226.1369)

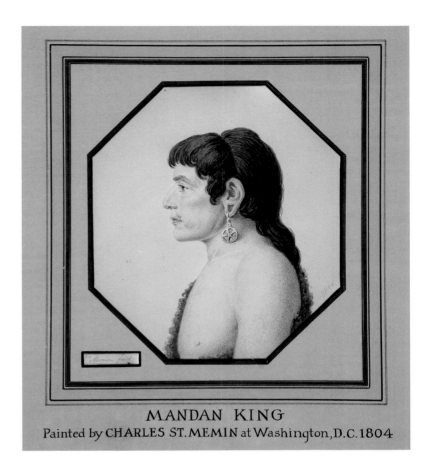

MANDAN KING
Painted by CHARLES ST. MEMIN at Washington, D.C. 1804

CHARLES BALTHAZAR JULIEN
FÉVRET DE SAINT-MÉMIN

9 *Mandan Queen* [Yellow Corn, Wife of Shahaka]

1807, watercolor on paper, 6¾ × 6 in.
(0226.1370)

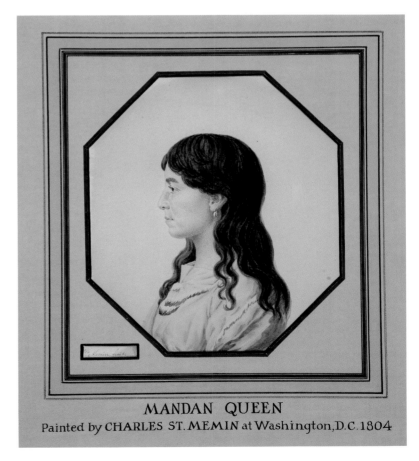

MANDAN QUEEN
Painted by CHARLES ST. MEMIN at Washington, D.C. 1804

work had a rudimentary and naive quality, Lewis excused himself by writing about the "rude materials" and the "rapidity with which he was obliged to labour" because of the limited time he had to make the portraits while at the treaties. In the advertisement that Lewis wrote for the series, dated July 20, 1835, he hoped the viewer would hold these excuses in account:

> as they are issued in their original state, that, whatever imperfections may be discoverable, will be kindly ascribed to the proper and inevitable cause.
>
> He would beg leave, moreover, to state, that he has the honor to be employed by the Indian Department expressly for the purpose. As regards the merits of their general character, and the fidelity of the costume, he can with confidence assure the public, that the resemblances of both are faithfully and accurately given.
>
> Copies from the principal *originals* were painted by Mr. King of Washington, and are now deposited in the War Office.[17]

Charles Bird King created many of the earliest nineteenth-century oil paintings of Native Americans. King studied under Benjamin West in England and Thomas Sully in America. He had a studio in Washington, D.C., at the time that he met Thomas McKenney from the Office of Indian Trade (later abolished and reincarnated as the Bureau of Indian Affairs in 1824). McKenney decided that portraits of Indians would be a popular attraction and, with King's portrait skills on call, he added portraits to the artifact collections of his Archives of the American Indian, the first museum in Washington and one of the first in the United States. King painted more than one hundred portraits for the government between 1821 and 1842. A fire in the Smithsonian Institution largely destroyed the collection in 1865. However, McKenney's personal collection also included copies of a number of King's works, which he used in illustrating his portfolio and book *History of the Indian Tribes of North America.* The paintings were first published as a portfolio of lithographs from 1837 to 1844 and then as a three-volume set of books from 1842 to 1844, entitled in full: *History of the Indian Tribes of North America, with Biographical Sketches and Anecdotes of the Principal Chiefs, Embellished with One Hundred and Twenty Portraits from the Indian Gallery in the Department of War at Washington* by Thomas L. McKenney and James Hall. McKenney published a lithograph (pl. 11) of King's 1837 painting *Wa-pel-la, Chief of the Musquakees* [Fox], about which McKenney and Hall wrote: "Wapella, whose name is derived from *Wapana,* meaning 'He of the Morning,' signed many treaties between the Fox and the United States, beginning with the Fort Armstrong treaty of September 3, 1822."[18]

King's original painting *David Vann* [Cherokee] (pl. 12) was also used as the source for the lithograph of Vann in McKenney and Hall's *History of the Indian Tribes of North America.* Vann became treasurer of the Cherokee Nation in the 1840s under John Ross, principal chief. Vann had "believed that the only way for the Cherokee to survive was to give up their territory and move to the lands beyond the Mississippi, which the government had solemnly promised would never hear the sound of a white man's voice."[19]

The McKenney and Hall volumes are an important visual record of portraits of leaders of the western tribes (who had originally occupied lands east of the Mississippi River). McKenney had arranged for the use of images from paintings, mostly by Charles Bird King and James Otto Lewis. James Hall wrote the text from McKenney's notes and interviews.[20] James Otto Lewis's *Port Folio* was printed only once, whereas the more finished appearance and completed biographical information of McKenney and Hall's treatment generated greater demand, and several folio and octavo editions were printed during the next few decades, beginning with its first publication in 1837.

Thomas McKenney had become the commissioner of Indian Trade in 1816 and became an inveterate collector of not only paintings but also artifacts. His museum was located in his office in the War Department building. His department was later disbanded, but in 1824 President James Monroe made him the first superintendent of the Bureau of Indian Affairs. Continually lobbying for better treatment of Indian people, McKenney warned Congress that the legislature should be concerned for the welfare and survival of the tribes and that, by treaty, they were under the protection of the government. After serving through the presidential term of John Adams, McKenney was dismissed by President Andrew Jackson in 1830. Jackson (seventh president, 1829–37) encouraged Congress to pass the Indian Removal Act. He signed it on May 26, 1830, forcing eastern tribes to move to Indian Territory (at that time including the eastern regions of Nebraska, Kansas, and Oklahoma).

James Otto Lewis and Charles Bird King were the first portrait artists of Indians to have their works published in large-format portfolios. But George Catlin was the first artist to travel the Missouri River with the intent of making a visual record of every aspect of Indian culture, including homes, clothing, ceremonies, and traditional ways. From 1830 to 1836, he traveled throughout the Great Plains and through Minnesota and the Great Lakes region, and he left an unsurpassed visual and written record. His most memorable voyage was on the *Yellowstone,* the first steamboat to voyage up the Missouri. Catlin was thus able to visit Mandan villages and travel on to Fort Union (located on what is today's North Dakota/Montana border) and the land of the Blackfeet. In 1837, the year after Catlin's journeys, an epidemic of smallpox at Fort Union rapidly decimated the native population throughout the region.

George Catlin grouped his Indian art into several categories, including portraits, landscapes, customs, and sports. His portraits were also of several types: head, head and shoulders, head to waist, and head to feet (full length). Catlin painted portraits of Indian leaders in the East and Midwest in addition to the West. His 1827 portrait *Red Jacket* [Sa-go-ye-wat-ha, Seneca] (pl. 13) reveals the stern character and obstinacy of the Seneca leader and orator who was concerned about the welfare of all people. In a council at Buffalo, New York, in 1805, Red Jacket spoke of the need for peaceful negotiations and the telling of truth: "Brother . . . you have been preaching to the white people in this place. These people are our neighbors: We are acquainted with them. We will wait a little while and see what effect your preaching has upon them. If we find it does them good, makes them honest and less disposed to cheat Indians,

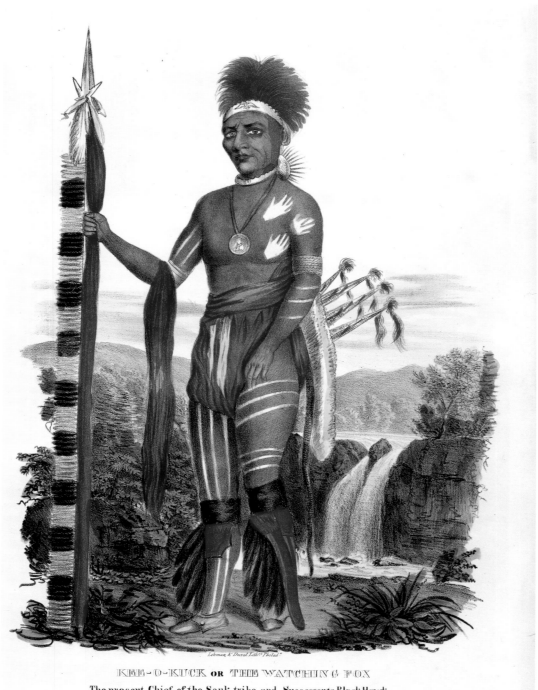

KEE-O-KUCK OR THE WATCHING FOX

The present Chief of the Sauk tribe and Successor to Black Hawk.

Painted by J. O. Lewis at the great treaty of Prairie du Chien. 1825

After JAMES OTTO LEWIS

10 "Kee-o-kuck or the Watching Fox, the present Chief of the Sauk tribe and Successor to Black Hawk"

Hand-colored lithograph, 19 × 11 in. (sheet size), in *Aboriginal Port Folio*, 1835 (2126.1769)

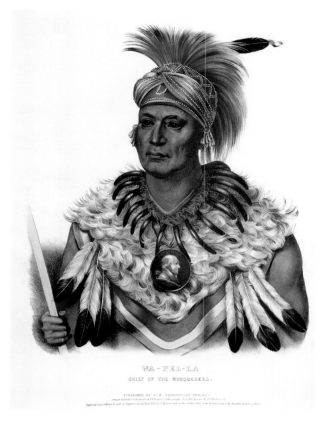

After CHARLES BIRD KING

11 "Wa-pel-la, Chief of the Musquakees [Fox]"

1837, hand-colored lithograph, 20 × 13¾ in. (sheet size),
in McKenney and Hall, *History of the Indian Tribes of
North America,* 1842 (2126.1815)

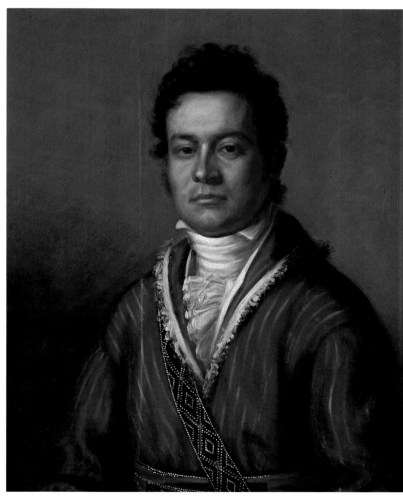

CHARLES BIRD KING

12 *David Vann* [Cherokee]

c. 1852, oil on wood panel, 18 × 14½ in. (0126.1193)

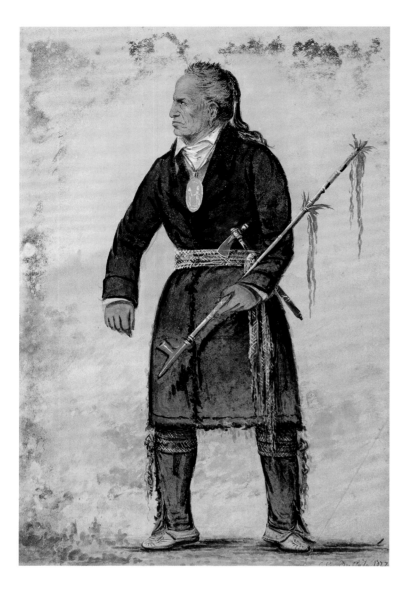

GEORGE CATLIN

13 *Red Jacket* [Sa-go-ye-wat-ha, Seneca]

1827, watercolor on mounted paper, 11¼ × 7½ in. (0226.1566)

we will consider again of what you have said." In 1824, recognizing the idea of expansionism, Red Jacket stated: "The red men knew nothing of trouble until it came from the white men; as soon as they crossed the great waters, they wanted our country. . . ."[21]

Catlin's travels to record as many tribal cultures as possible took him to a number of trading and military posts. He found members of the Piankashaw tribe and asked Men-són-se-ah, the Left Hand, to pose for a portrait (pl. 14), "probably painted at Fort Leavenworth in 1830."[22] Catlin wrote that the "Pi-an-ke-shaws" were a "remnant" of their former numbers. They once occupied the "states of Illinois and Indiana, . . . [they] have also recently sold out their country to the Government, and are under contract to move to the west of the Missouri, in the vicinity of Fort Leavenworth. . . . *Men-són-se-ah* (the left hand), [is] a fierce looking and very distinguished warrior . . . [of] this reduced and enfeebled tribe, which do not number more than 170 persons at this time [1830]."[23]

Catlin visited Fort Leavenworth first in 1830 and again in 1832, when he painted *Wah-ro-née-sah, the Surrounder, Oto Chief* (pl. 15), whom he described as "quite an old man; his shirt made of skin of a grizzly bear, with the claws on."[24]

Catlin's portrait paintings of full figures accurately render features in both face and dress. Traveling up the Missouri in 1836, Catlin noted:

> I have also secured the portraits of Ee-hee-a-duck-chee-a (He who ties his hair before) [pl. 16] and Pa-ris-ka-roo-pa (the two Crows) . . . both of which are exhibiting extraordinary instances of natural hair reaching to the ground . . . pecularities belonging almost exclusively to this tribe. . . . I offer them as extraordinary and rare occurrences amongst the tribe . . . and also in the elegance of dress and ornament The Crows are generally handsome, and comfortably clad; every man in the nation oils his hair with a profusion of bear's grease, and promotes its growth to the utmost of his ability; and the greater part of them cultivate it down on to the calf of the leg, whilst a few are able to make it sweep the ground.[25]

George Catlin wanted to bring the plight of Indian people to the world, to champion their cause and promote friendship. He did that through having firsthand experience, by visiting forty-eight tribes to paint portraits and scenes of "customs and manners," and by writing a number of "letters and notes."[26] To bolster his writings, in 1839 he began exhibiting his "Indian Gallery" in Europe, particularly in England and France, showing both his paintings and the numerous artifacts he had collected during his travels among the Indians. He featured Indian dancers, gave lectures, distributed prints and portfolios, and sold paintings. In the United States, he petitioned Congress to purchase his work and to show more empathy toward

GEORGE CATLIN

14 *Men-són-se-ah, the Left Hand, Piankashaw*

1830, watercolor on paper, 6 × 4⅞ in. (0226.1500)

GEORGE CATLIN

15 *Wah-ro-née-sah, the Surrounder, Oto Chief*

1832, watercolor on paper, 5¾ × 5¼ in. (0226.1542)

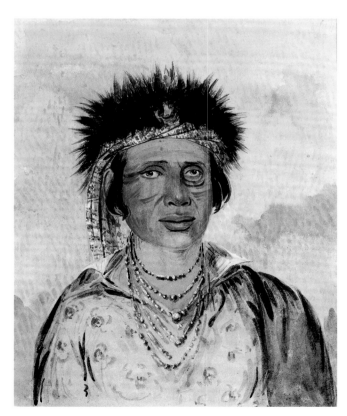

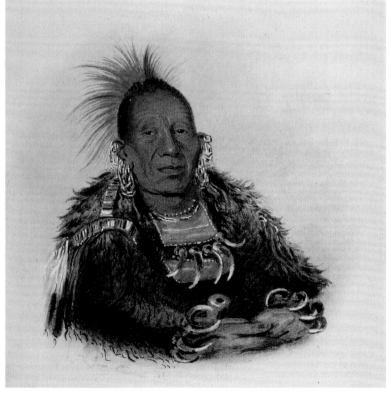

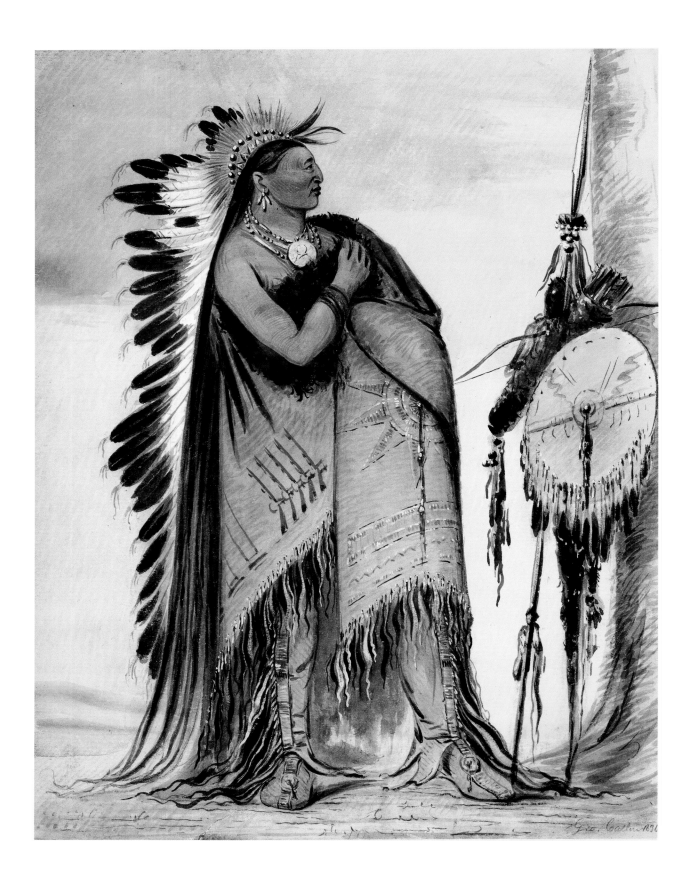

GEORGE CATLIN

16 *Ee-hee-a-duck-chee-a, He Who Ties His Hair Before* [Crow]

1836, watercolor on paper, 10¾ × 8¼ in. (0226.1548)

the tribes. His American and European exhibitions inspired other artists from both continents to make westward journeys for themselves.

Swiss artist Karl Bodmer explored the same portrait compositional conventions used by Catlin and other portrait artists, including the three-quarter view, which gives the onlooker a partial profile of the forehead, nose, and chin as well as a glimpse of the opposite eye and cheek. Both a profile and a three-quarter view are used by Karl Bodmer in his double portrait of *Mássika, Saki* [Sauk] *Indian, and Wakusásse, Musquake* [Fox] *Indian* (pl. 17).

Bodmer had met the two Indian men in Saint Louis before he set off on his journey up the Missouri River in 1833 with German Prince Maximilian of Wied-Neuwied (1782–1867), a scientist and explorer, riding the same steamboat Catlin had traveled in the year before. The first Indians encountered by the artist and the scientist on their journey,[27] Mássika and Wakusásse had arrived in Saint Louis in March 1833 to meet with the authorities and William Clark (superintendent of Indian Affairs from 1822 until his death in 1838) to plead for the release of Black

After KARL BODMER

17 "Mássika, Saki [Sauk] Indian, and Wakusásse, Musquake [Fox] Indian"
1844, hand-colored aquatint, etching, mezzotint, and stipple on paper, 15⅞ × 19⅜ in. (plate mark), in *Travels in the Interior of North America,* 1844 (4576.91.37B)

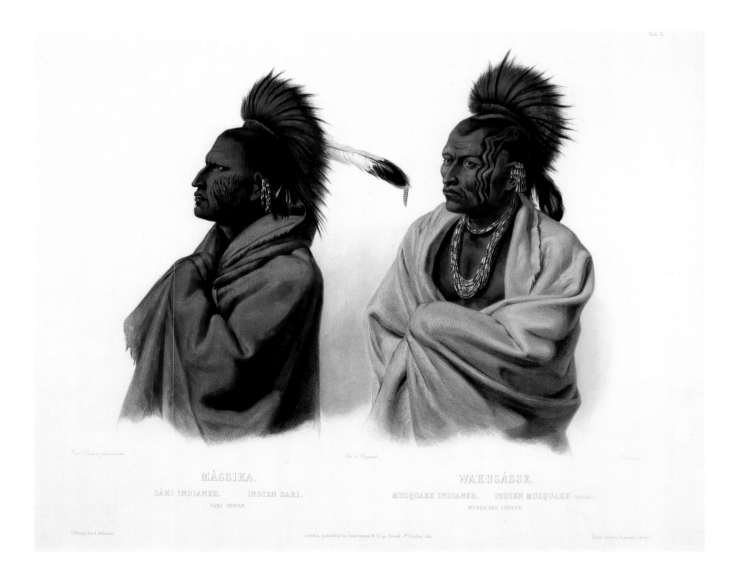

MÁSSIKA.

SAKI INDIANER. INDIEN SAKI.

SAKI INDIAN

WAKUSÁSSE.

MUSQUAKE INDIANER. INDIEN MUSQUAKE

MUSQUAKE INDIAN

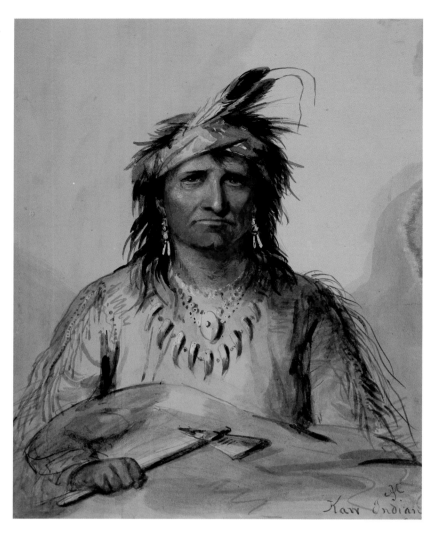

ALFRED JACOB MILLER
18 *Kaw* [Kansa] *Indian*
Undated, watercolor on paper, 11 × 8¼ in.
(0226.1037)

Hawk, a Sauk and Fox leader. Black Hawk refused to recognize treaties, and he had incited the Black Hawk War and was taken prisoner on August 2, 1832. Having become a celebrity, Black Hawk released his autobiography in 1833. Speaking of personal deprivations he had to submit to as a prisoner, he wrote a dedication to an American general: "The changes of fortune, and vicissitudes of war, made you my conqueror. . . . The path to glory is rough, and many gloomy hours obscure it. May the Great Spirit shed light on yours—and that you may never experience the humility that the power of the American government has reduced me to, is the wish of him, who, in his native forests, was once as proud and bold as yourself."[28]

Fur trapping was still a common profession in the northern Rocky Mountains when Bodmer and Maximilian made their trip. Maximilian made only a single trip to the West from 1833 to 1834, but Sir William Drummond Stewart of Scotland traveled to the American West on several occasions to attend the fur trappers' rendezvous, an annual event between 1825 and 1840. The rendezvous was staged on the western side of the "the Mountains of the Wind," the Wind River Range of the Rocky Mountains in what is now western Wyoming. It was an occasion for both Indian and white trappers to sell pelts to the fur companies. For Drummond's attendance at the 1837 rendezvous, he had the foresight to hire artist Alfred Jacob Miller (1810–1874) to travel with his caravan and record images of the trip, where

Miller found the rendezvous on Horse Creek close by the upper Green River, western side of the Wind River Range a strange, riotous bacchanal where drunkenness and letchery abounded. . . . Actually, the rendezvous was like some trade fair of the Middle Ages where wagon loads of trinkets from "civilization" were swapped for beaver and otter skins that would eventually find their way to London and far-off Leipzig in central Europe. At the same time contests of skill from drinking bouts to horse races were held. Wagering and good fellowship between red men and white abounded on this once-a-year occasion.[29]

Stewart had originally introduced himself to Miller a day after viewing his work at his New Orleans studio. And thereby Miller became the first professional artist to journey overland to the western Rocky Mountains and the only one to witness a fur traders' rendezvous. He created more than five hundred field studies during his western journey, an output undoubtedly due to the fact that "Stewart had assigned him a man to tend to his horse and pitch his tent, so that he could paint more pictures unimpeded by trivial duties."[30]

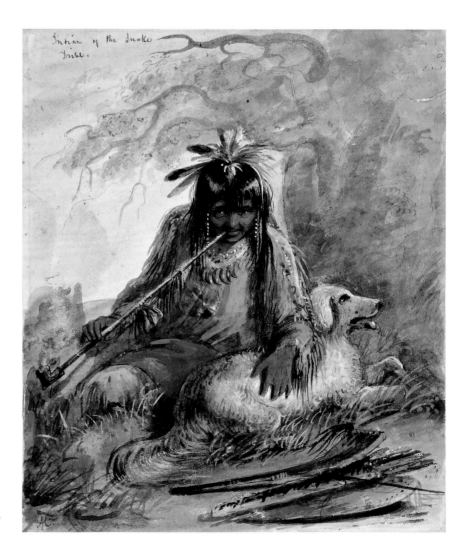

ALFRED JACOB MILLER

19 *Indian of the Snake* [Shoshone] *Tribe*

Undated, watercolor on paper, 10¼ × 8¼ in. (0226.1052)

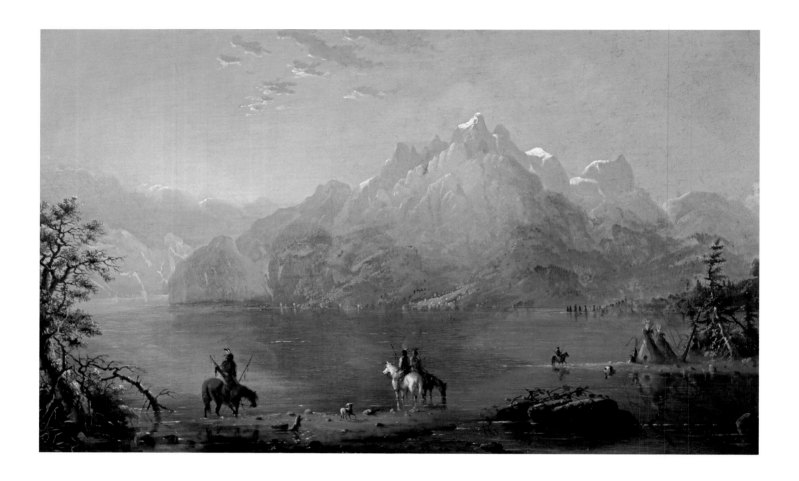

ALFRED JACOB MILLER

20 *Indians on Green River*

Undated, oil on canvas, 21½ × 36 in.
(0126.732)

In painting portraits, Miller used the usual compositional portrait conventions. He painted many of his portraits with the subject face forward (full face), but some were painted in profile and others were painted as if part of a living still life. Two of these compositional methods are seen in *Kaw* [Kansa] *Indian* (pl. 18) and *Indian of the Snake* [Shoshone] *Tribe* (pl. 19).

Miller also created a number of paintings of lakes high up the west side of the Wind River Range, usually with Indians prominently featured, as in *Indians on Green River* (pl. 20). These lakes were seen by the artist and the Stewart party after the rendezvous. Miller seemingly basked in the serene, "close to God" scenes impressed on him during those days, and he portrayed the mountains and the lakes at all hours, often with Indians and riders dwarfed by their grandeur. Had he painted these works in monumental size, his paintings would have rivaled Albert Bierstadt's for surreal, serene, and dreamlike appeal.

Returning to his studio in New Orleans after his 1837 journey, and then later back home in his native Baltimore, Miller developed his small studies into larger oil paintings and watercolors, never forgetting scenes such as *Buffalo Hunt* (pl. 21) and other captivating images from his only sojourn to the West. He continued painting western scenes throughout his career, including a number of commissions for William Drummond Stewart, featuring scenes of the American bison (buffalo). His dramatic scenes of Indians on horseback, racing or hunting bison, also spoke

of the new knowledge he gained during his sojourn in the West. Bison hunting was not a sport to Indian people; it was a way of life and livelihood. The bison provided food, hide clothing and house covering, horn and bone utensils, ropes of hair, sinew thread, curing potions, and other necessities of daily life.

Before the late 1800s, the typical means artists used to picture a horse galloping at full speed was to portray it with forelegs thrown forward and hind legs thrown backward. In *Lassoing Wild Horses* (pl. 22), Miller depicts the ease the rider feels as he becomes one with his horse, charging with a reckless abandon. As the Indian drives ahead and swings his lasso, his quiver and trade blanket—newly acquired from the rendezvous—blow in the wind. Everything in the scene appears to move forward at a quickened pace. Nothing will prevent the man from lassoing his prize.

Early in his career, Miller had gone to Europe to study in Paris and Rome, and afterward he established his studio in America, first in Baltimore and then in New Orleans. A number of European artists also settled in America to paint: Carl Wimar, Emanuel Leutze (1816–1868), and Albert Bierstadt (1830–1902) were born in Germany but came to the United States. All were inspired by their training at the Düsseldorf Academy of Art to champion both heroic size and theatricality of style. They were emboldened to paint images of grand scenes in panoramic landscapes

ALFRED JACOB MILLER
21 *Buffalo Hunt*
1840, oil on canvas, 30 × 44 in.
(0126.739)

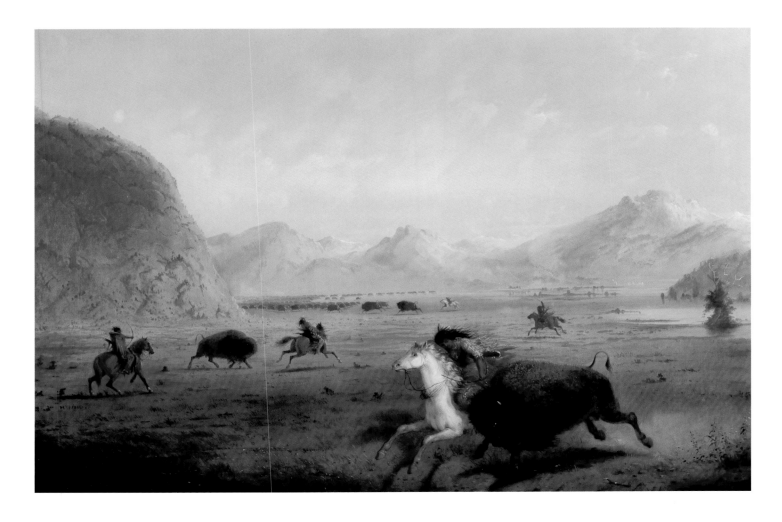

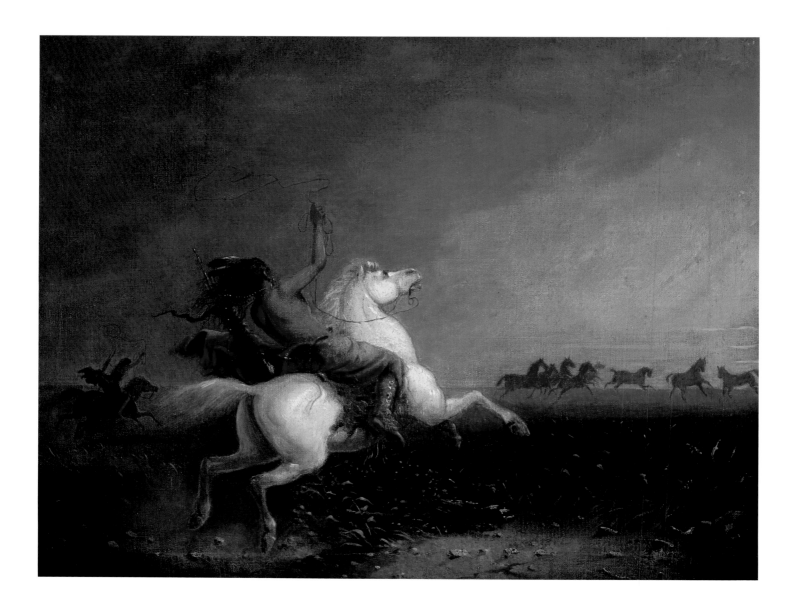

ALFRED JACOB MILLER

22 *Lassoing Wild Horses*

Undated, oil on canvas, 27 × 34 in.
(0126.740)

motivated by, but not necessarily true to, the American landscapes they saw. The enormity of their landscapes dwarfed the animal and human figures placed in them, as seen in Wimar's *Indian Encampment on the Big Bend of the Missouri River* (pl. 23).

At age twelve Carl Wimar emigrated from Germany to Saint Louis with his mother. At age twenty-one he returned to Germany and studied under Josef Fay and Emanuel Leutze at Düsseldorf Academy.[31] In his 1858 and 1859 voyages up the Missouri River, he must have witnessed a scene similar to *Indian Encampment on the Big Bend of the Missouri River.* The location is the Grand Detour in central South Dakota, also referred to as the Narrows, where the Missouri River makes an oxbow, flowing back north before continuing south. To capture the dimension and expansiveness of the prairie and provide balance to the overall image, Wimar used a compositional construction common to his European training. He selected a viewpoint above the foreground and at eye level to the horizon, dividing the painting just above the centerline delineating land and sky. The scene portrays

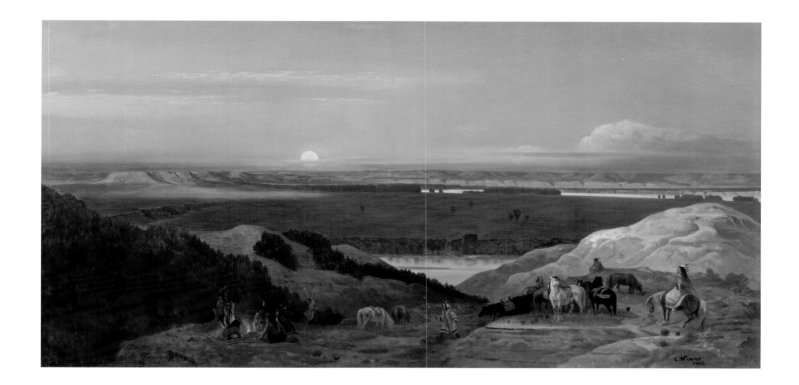

serenity in the calm bearing of the men and their horses and in the minimal qualities of the distant landscape.

Personal experience was key inspiration to the work of Wimar and many other artists who painted scenes of the West and Indian life. The paintings by Seth Eastman (1808–1875) of Indian subjects are based on his experiences in the old Northwest Territory (now Wisconsin and Minnesota). A career army officer, Eastman graduated from West Point, where cadets were taught basic drawing skills, perspective, shading, and watercolor techniques to improve their mapmaking abilities. Eastman became an accomplished painter. For a time in the 1830s, he was a drawing instructor at the U.S. Military Academy. In 1838 he was elected an honorary member of the National Academy of Design in New York City. Among his works are more than twenty-five paintings, including nine on the subject of Indian life, that Eastman made for the capitol complex in Washington, D.C.[32]

Seth Eastman illustrated the writings of his wife, Mary Eastman, while he was a captain posted at Fort Snelling from 1841 to 1848. In 1849 Mary published her first book, *Dahcotah; or, Life and Legends of the Sioux around Fort Snelling.* The book was based on Mary's interviews with the Sioux, whose language she had learned to speak. Seth and Mary Eastman believed the Indians were a dignified and noble people and wanted others to understand them in the same way. A celebration of Indian life, legends, and thought, the book includes an image of *Maiden Rock* (pl. 24) and the story of Winona, who leaped to her death from the four-hundred-foot precipice rather than marry a man who had been chosen for her and whom she did not love. (Maiden Rock is on the eastern shore of Lake Pepin on the Mississippi River, some fifty miles southeast of Fort Snelling, now in Minneapolis.) In her story

CARL WIMAR

23 *Indian Encampment on the Big Bend of the Missouri River*
1860, oil on canvas, 25 × 49 in.
(0126.1598)

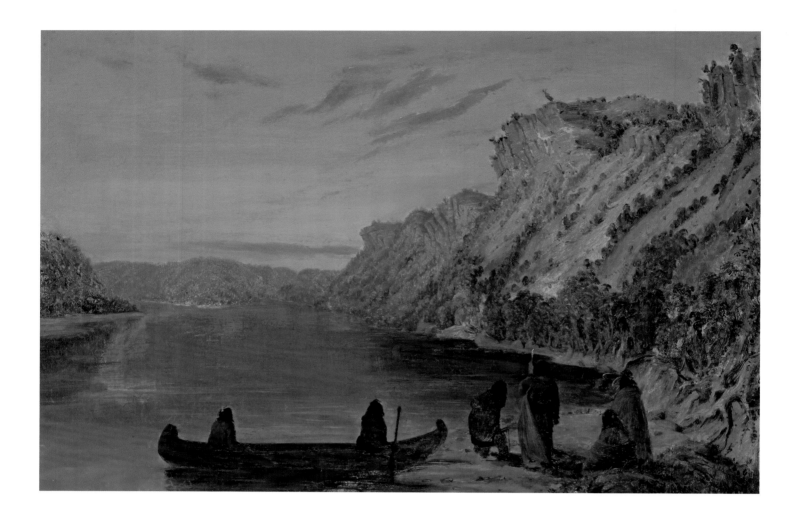

SETH EASTMAN
24 *Maiden Rock*

Undated, oil on canvas, 17 × 25 in.
(0126.1124)

"The Maiden's Rock; or Wenona's Leap," Mary Eastman wrote: "About one hundred and fifty years ago [1700] the band of Dahcotahs to which Wenona belonged, lived near Fort Snelling. . . . A young girl of this band had received repeated offers of marriage from a Dahcotah, whom she hated with the same degree of intensity that she loved his rival. / She dared not marry the object of her choice, for she knew it would subject herself and him to persecutions of her family." Her parents wanted her to marry "the best hunter of the tribe. . . . She knew it would be useless to contend." At the top edge of the rock, she said, "You have forced me to leave you. . . . [Y]ou would have forced me to marry a man I hated. . . . [W]hen they were quite near, so that they held out their arms towards her in their eagerness to draw her from her dangerous station, she threw herself from the rock."[33]

For nineteenth-century artists, folios and books were important means of presenting their work and making a living. News of Indians and western characters (such as mountain men and explorers) and of the geography and the science (biology, ethnology, botany, and geology) of the West were all ripe subjects for artists, journalists, and publishers. Special publications and portfolios of images on the subjects were well received. News of the West also spread across the ocean, attracting adventurers and immigrants from far and wide. John James Audubon

(1785–1851) sold his first subscriptions to his *Birds of America* (1827–38) in England and France. Produced in double elephant folio size and including four hundred thirty-five hand-colored plates, it was the largest publication of its kind, printed on the largest sheets of paper available at the time: 39½ by 29½ inches. In 1843 he journeyed on the steamboat *Omega* up the Missouri River from Saint Louis to Fort Union in only forty-three days.[34] (Lewis and Clark reached the same point in fifty weeks.) During the journey Audubon searched for new species of quadrupeds to draw for his next publication, *The Viviparous Quadrupeds of North America.*[35] Although all the paintings he made for *Birds of America* were done in watercolor, to finance his publications he sold oil paintings that he called his "potboilers." One of those was *Pair of Cooper's Hawk* (pl. 25), painted similarly to the way it was illustrated in his portfolio. Audubon first painted the hawks in watercolor in 1826 in Louisiana and later repainted them in oil.

In a letter of introduction Thomas Sully wrote for Audubon in 1824, he penned: "for copiousness and talent . . . [his series of bird paintings] bid fair in my estimation to surpass all that has yet been done, at least in this country."[36] In August 1826, the first year of his three-year visit to England to seek an engraver and subscribers for *Birds of America,* John James Audubon wrote to his wife, Lucy, in Louisiana: "My wish is to publish them in London. . . . [To support myself in England] I will follow a general round of remunerating exhibitions and take the proceeds home. . . . I will keep myself busy at drawing and painting birds & quadrupeds for sale all the time, and I hope thus to do well."[37]

John James Audubon recognized the importance of making written and visual records of the landscape. He often incorporated landscapes into the background of his bird portraits. He arrived in the United States from France in 1803, the same year the Louisiana Territory was purchased. In 1833, traveling down the Ohio River, he lamented the changes that the encroachment of settlers had made on the landscape. He later wrote: "When I think of these times, and call back to my mind the grandeur and beauty of those almost uninhabited shores . . . when I remember that these extraordinary changes have all taken place in the short period of twenty years, I pause, wonder, and although I know all that to be fact, can scarcely believe its reality. . . . I feel with regret that there are on record no satisfactory accounts [written or visual] of the state of that portion of the country, when [before] our people first settled it."[38] Fortunately, the West beyond the Mississippi was recorded for posterity by a number of explorer-artists.

Audubon's elder of two sons, John Woodhouse Audubon (1812–1862), was taught to paint by his father and helped him with his projects. J. W. Audubon made his own journey into the West from 1845 to 1846 on a *Quadrupeds* specimen-collecting expedition to Texas. He was guided by a Delaware Indian who had been on a number of western expeditions as an employee of the American Fur Company. J. W. Audubon's portrait *Black Beaver (Delaware Chief)* (pl. 26) reveals the character of not only the guide but also the desolate landscape through which they trekked.[39]

In the early 1840s, about the time that John James Audubon made a painting of a beaver as one of the illustrations for *The Viviparous Quadrupeds of North America,*

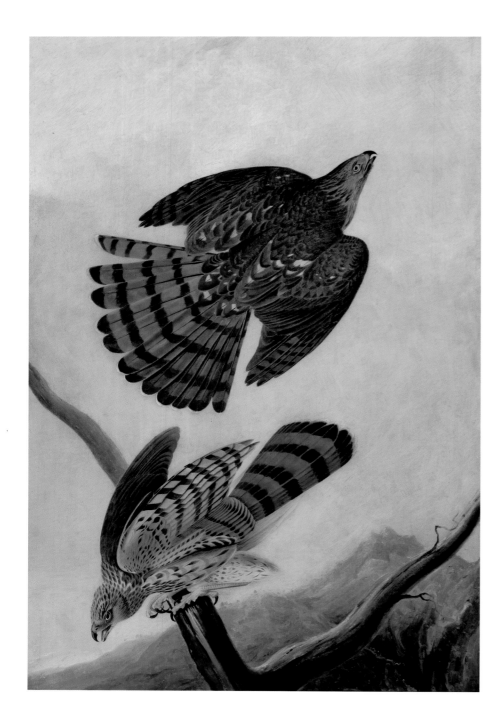

JOHN JAMES AUDUBON
25 *Pair of Cooper's Hawk*

Undated, oil on canvas, 39 × 26 in.
(0126.2321)

the commerce in beaver pelts declined, basically putting an end to the fur trade in the Rocky Mountains (although there was another rendezvous in 1843, and William Drummond Stewart was there). The first half of the route to the rendezvous was later used by wagon trains. Blazed by mountain men and fur traders, the Oregon Trail received the first wagons to the West as early as 1832, and its great migrations were under way in earnest by 1843, with hundreds of people on each wagon train.

The next great migration to the West was put into motion by the discovery of gold in January 1848 at John Sutter's mill in California, near Coloma, about forty miles east northeast of Sacramento. Subsequently gold was discovered throughout the Sierra Nevada Mountains, and one of the discoveries was at a place that came to be known as Chinese Camp (some thirty-five miles east of Modesto). The discovery

of gold attracted potential miners from around the world—Europeans, South Americans, and Asians among them. Chinese miners had hopes of "bettering their lives," and 25,000 Chinese "had arrived in the gold camps by 1852." By state statute, the Chinese and all "foreigners [and Indians]" could not "testify in court in cases involving whites." They could be workers, "but if they moved into areas of the labor force that whites considered off-limits, it was at the peril of their lives." They were excluded from any "mining activity except in areas already picked over and abandoned by whites."[40] It was not unusual to find Chinese miners settled with their families directly at sites to work mines abandoned by others who thought they had been played out, and their diligence was rewarded: "By 1863, when most white prospectors were gone, Chinese immigrants owned most California placer mines."[41]

Chinese Camp, California, was a placer-mining district discovered in 1849. Placer mining involves panning and sluicing to separate gold from gravel, rock, and sand. In his drawing of *Chinese Mining Camp* (pl. 27), John Ross Browne (1821–1875) pictures workers breaking rock in a stream and separating the gold from the debris with a sluice. In the house on the left, women appear to be preparing a meal.

Born in Ireland, Browne came to America at age eleven with his parents and settled in Louisville, Kentucky. He became a writer and illustrator for travel books

JOHN WOODHOUSE AUDUBON
26 *Black Beaver (Delaware Chief)*
Undated, oil on canvas, 22 × 28 in.
(0126.1565)

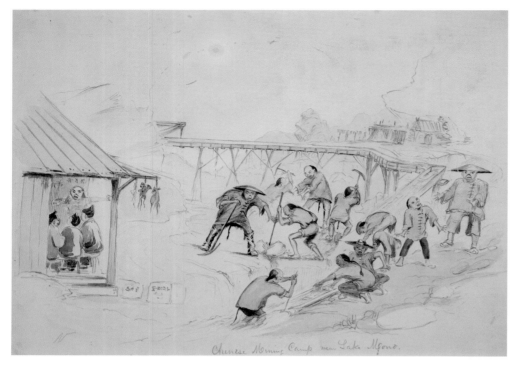

JOHN ROSS BROWNE

27 *Chinese Mining Camp*

Undated, ink wash on paper, 11 × 14¾ in.
(0236.723)

and publications such as *Harper's Monthly*.[42] Browne was one of many writers and illustrators whose articles and paintings were published in journals and magazines. The interest of the eastern public was unquenchable for news of the West in the first half of the nineteenth century. Browne's drawing *New Furnices* [Furnaces] (pl. 28), possibly a study for an illustration, shows several furnaces of the type that were built near major gold strikes to smelt the ore from which the pure gold was extracted.

Western commerce in fur trading preceded the gold miners of California by more than four decades. As a fur trading post first named Fort William, Fort Laramie was constructed in 1834 at the confluence of the North Platte and Laramie rivers (in what is today southeastern Wyoming) near an Indian trade route that was also used by trappers and mountain men. Alfred Jacob Miller was the first and only professional artist to see Fort Laramie in its original state, three years after its construction and before it was replaced by another structure made not with log palisades but with earth in the form of adobe bricks. His painting *Fort Laramie* (pl. 29) portrays Indians engaged in races, games, and encampments, waiting for the trading caravan. Miller described the scene: "Over the front entrance is a large block house in which is placed a cannon. The interior of the fort is about 150 feet square surrounded by small cabins whose roofs reach within three feet of the top of the palisades against which they abut; the Indians encamp in great numbers here three or four times a year, bringing peltries to be exchanged for dry goods, beads, and alcohol."[43]

On the outgoing journey to the 1837 rendezvous, Miller and William Stewart's party camped for several days at Fort Laramie. Miller described the *Interior of Fort Laramie* (pl. 30): "The interior view is from the great entrance looking west and embraces more than half the court area. When this space is filled with Indians and

traders, as it is at stated periods, the scene is lively and interesting. . . . A Saturnalia is held the first day and some excesses committed, but after this, trading goes briskly forward."[44]

Miller knew how to please his patron. He painted many views of Stewart holding court with the Indians or the Indians paying homage to Stewart's presence at the gathering. One such meeting is pictured in *Sir William Drummond Stewart Meeting Indian Chief* (pl. 31). Stewart is seen stretching out the hand of fellowship while the Indians fire their rifles in the air in greeting. Stewart knew the value of trade and prestige. Before departing Saint Louis, he purchased trade items (from weapons to beads) and outfitted himself and his men with the best "mountain man" clothing, camping gear, tents, and incidentals. Among the particularly impressive incidentals were the Persian rugs he brought along for the floor of his tent. The equipment and outfitting for his forty-five men and twenty carts totaled more than $20,000 ($336,000 today).[45] Anything he did not use, Stewart gave away when he returned to Saint Louis. The addition of an artist to document his trip was a boon to the historical record. Miller followed Catlin and Bodmer as the third professional artist to travel as far west and the first to journey across the Continental Divide.

Long journeys bring on thirst, the subject of Miller's *The Thirsty Trapper* (pl. 32), depicting Stewart accepting a cup of water from a young Indian woman, likely a Shoshone. Behind Stewart, and astride a mule, is probably Auguste, a French Canadian of Stewart's party, who served as Stewart's assistant. Having made the trip to rendezvous each of the previous four years, Stewart came to understand some of the language and signs of the Indians he encountered. *A Snake Indian Giving a*

JOHN ROSS BROWNE

28 *New Furnices* [Furnaces]

Undated, ink wash on paper, 13¼ × 15⅞ in. (0236.722)

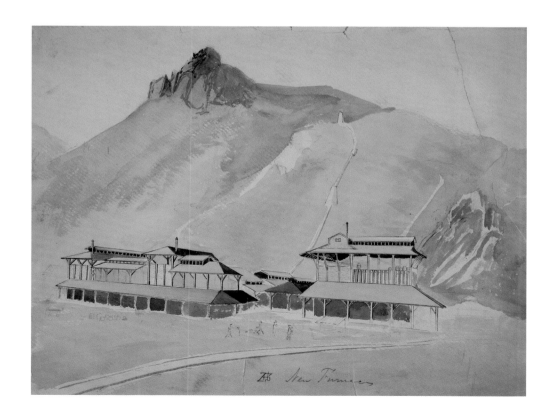

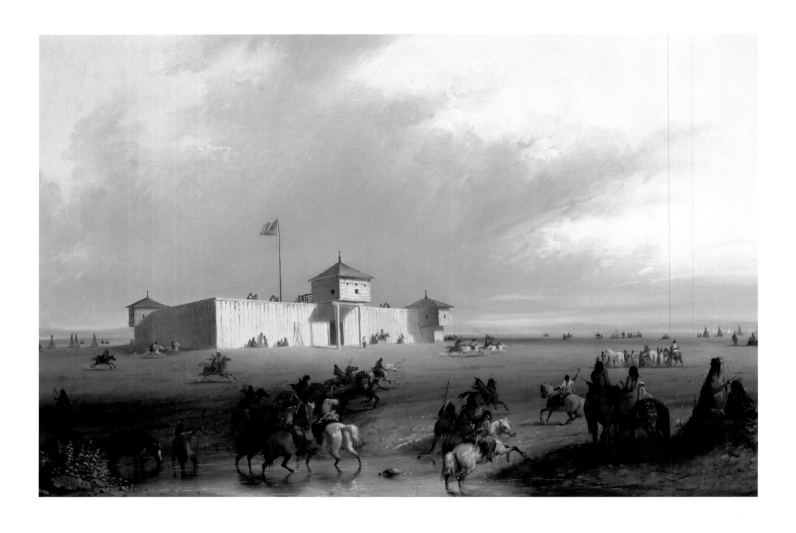

ALFRED JACOB MILLER

29 *Fort Laramie*

1851, oil on canvas, 18 × 27 in. (0126.727)

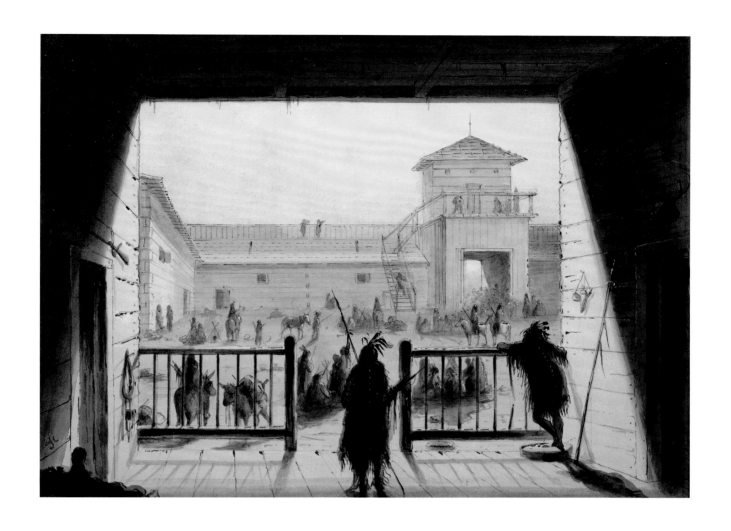

ALFRED JACOB MILLER

30 *Interior of Fort Laramie*

c. 1837, watercolor on paper, 10⅝ × 14⅛ in.
(0226.1067)

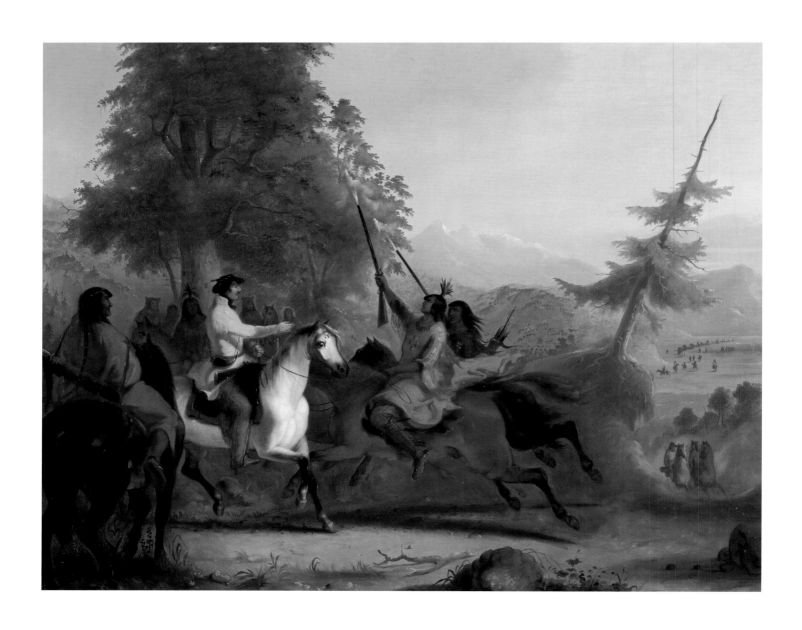

ALFRED JACOB MILLER

31 *Sir William Drummond Stewart Meeting Indian Chief*

Undated, oil on canvas, 33 × 42½ in. (0126.738)

Description of a Party Who Have Previously Passed by Trails Left on the Ground (pl. 33) is a portrayal of communication as the "trails left on the ground" are interpreted for Stewart. In Miller's words, the Indian people

> show an amazing facility in tracing the passage of a man or beast, either over leaves, grass, or the earth, and describe accurately from foot-prints, ruts, and other impressions left on the ground (if recent), how many persons, the number of horses or mules, the number of lodges, whether whites or Indians, and numerous other particulars, with a certainty and decision most remarkable. This wonderful power can only be attained by close attention, unwearied patience, and long experience.
>
> The subject of the sketch is a Snake Indian describing from certain marks on the ground, the particulars of a party who have passed in advance.[46]

During *Trappers Threatened by Indians* (pl. 34), Stewart and his personal hunter, Antoine Clement (a half Cree), stand unshakable under the taunting of Crow Indians. Stewart had experienced the incident on an earlier visit to rendezvous and asked Miller to illustrate the scene. According to Miller, "They [the Crows] carried off stock, pelts, and other property. . . . As Stewart described the incident, the Crow medicine man had told the braves that, if they struck the first blow, they could not win. Thus, they had to provoke Stewart or someone in his party. . . . Stewart stood firm, refusing to strike." The Crows eventually returned "most of what they had taken."[47]

Miller's painting *Threatened Attack on the Caravan by a Horde of Indians* (pl. 35) reveals a similar kind of taunting, but this provocation is from horseback. However, this may not be a threat at all but perhaps a play put on by the Indians (who would later bargain for trade goods). The caravan remains calm while Stewart (on the white horse) and his men view the "horde of Indians." As in the previous "threat," Stewart's men do not appear to be frightened, do not raise their weapons in fear, and do not force their horses into a gallop to escape. Regarding the "horde of Indians," Miller wrote: "A cloud of dust soon divulged a piratical horde . . . coming down on us at top speed, armed to the teeth, and when they reached us, they commenced riding around in a menacing manner."[48] The same type of event occurred at a different time as they approached their rendezvous campsite, when "a squadron of roughly dressed men rode directly down upon them, firing rifles and pistols with abandon. They weren't Indians but mountain men come to welcome them to rendezvous."[49] The Indians knew, from Stewart's own words, the distance he traveled to be a guest at the rendezvous, and they paid homage to that and to his rank as they paraded by his tent. Miller painted the scene (more than once) for posterity in *Indian Procession in Honor of Captain W. D. Stewart near the Rocky Mountains* (pl. 36).

Miller left a captivating visual record of his experiences in the West. Of the period prior to 1840, it is the only visual record made by a professional artist who traveled beyond the Continental Divide to capture the fur-trapping era of mountain men and Indians and frontier trade. The Goetzmanns described it well in *The West of the Imagination:* "In the hundreds of paintings he painted that year, he was

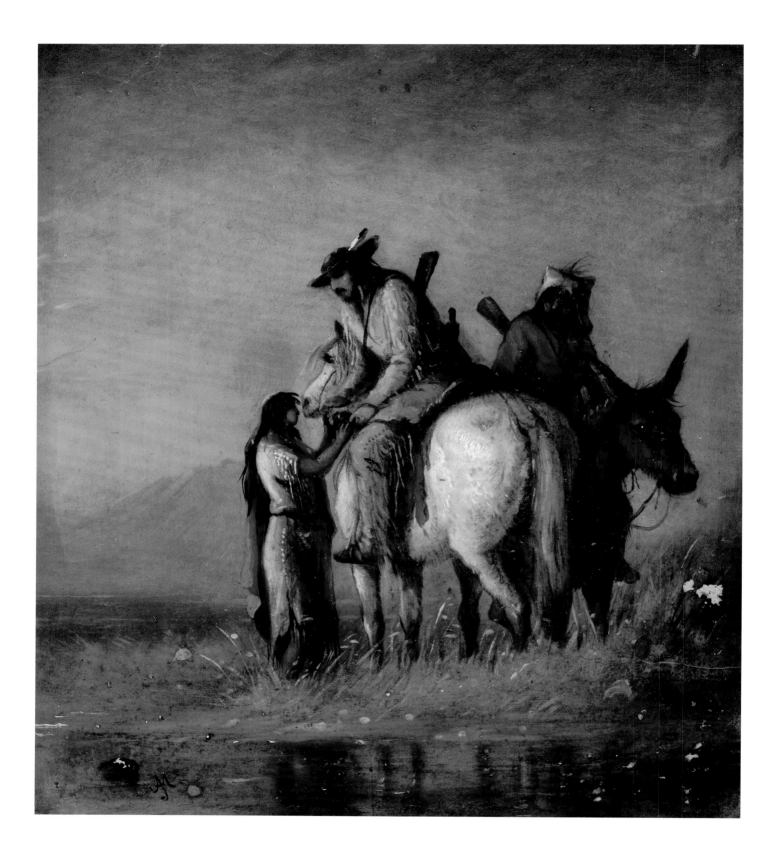

ALFRED JACOB MILLER

32 *The Thirsty Trapper*

Undated, oil on paper, 9⅛ × 8 in. (0136.743)

ALFRED JACOB MILLER

33 *A Snake Indian Giving a Description of a Party Who Have Previously Passed by Trails Left on the Ground*

Undated, watercolor on paper, 11 × 9⅛ in. (0236.1072)

A Snake Indian giving a
description of a party who
have previously passed — by
trails left on the ground.

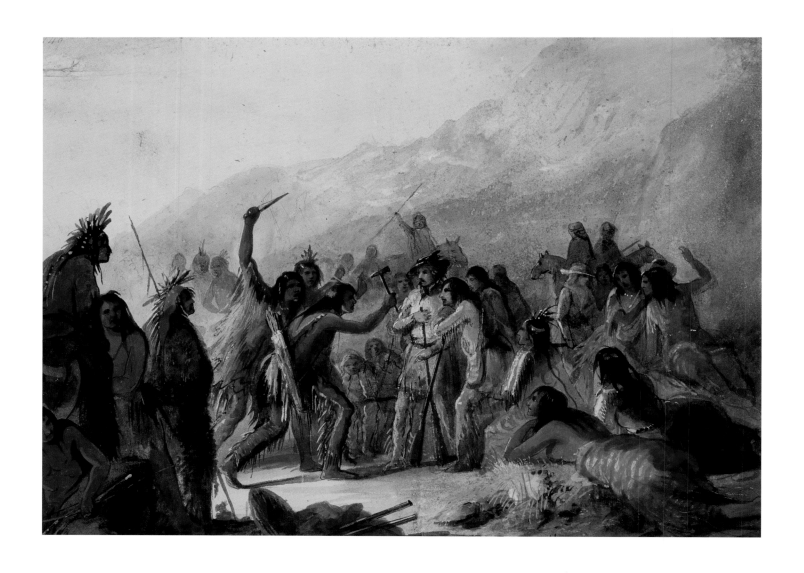

ALFRED JACOB MILLER

34 *Trappers Threatened by Indians*

Undated, watercolor on paper, 9⁹⁄₁₆ × 12⅞ in.
(0236.1094)

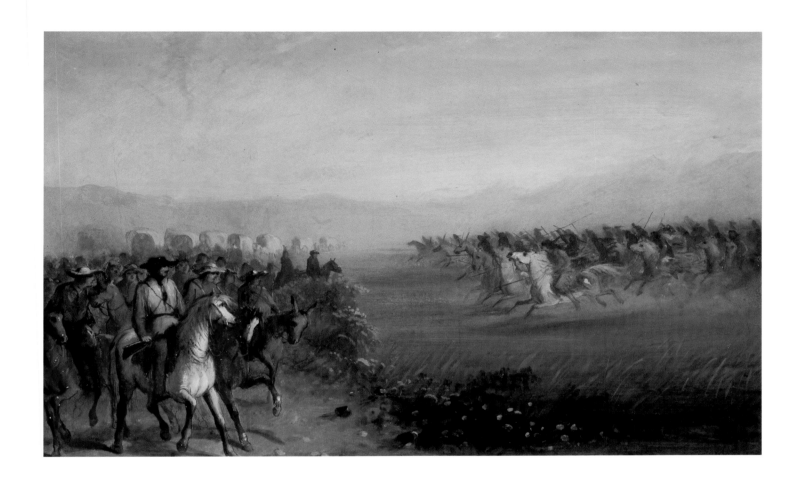

ALFRED JACOB MILLER

35 *Threatened Attack on the Caravan by a Horde of Indians*

Undated, oil on paper, 9 × 14¼ in. (0136.2429)

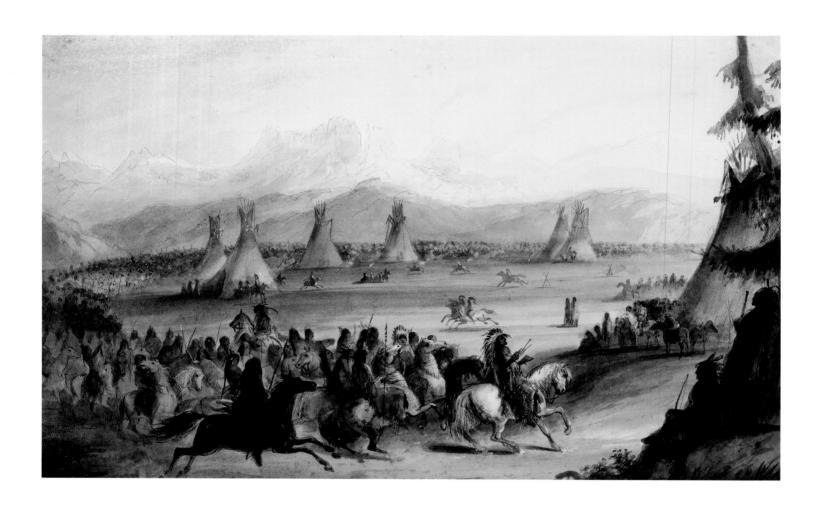

ALFRED JACOB MILLER

36 *Indian Procession in Honor of Captain*
W. D. Stewart near the Rocky Mountains

Undated, watercolor on paper, 10 × 15 in. (0236.1092)

painting a dream. And though he didn't know it, he was painting a way of life that was about to vanish forever. The Rocky Mountain fur trade had passed its zenith, and in painting the rendezvous of 1837, Miller produced what turned out to be historic views of its last great gathering."[50]

Some fifteen years before Stewart and Miller traveled to the rendezvous, Peter Rindisbacher (1806–1834) became the first of several Swiss artists (including Karl Bodmer and Rudolph Kurz [1818–1871]) to put their stamp on the art proceeding out of their experiences in the American West. With his parents, Rindisbacher immigrated to Canada in 1821 to live at Red River Colony (now Winnipeg, Manitoba). His father encouraged his art studies, and before he was twenty he began working on commissions, making a record of life at the colony. Seven years later he moved to Fort Snelling, on the northwest side of the confluence of the Mississippi and Minnesota rivers, then to Wisconsin Territory. He finally settled in Saint Louis where he set up a studio. A self-trained artist, Rindisbacher concentrated on careful craftsmanship, composition, color, and detail. His work was more reportorial in nature than that of academically trained artists. He died at age twenty-eight, just as he was developing his talents toward aesthetic as well as design sensibilities.[51]

Like many artists of the West, Rindisbacher is known to have seen and experienced most of the scenes that he painted. Comfortable family scenes in the tepee lodges of the Sioux are evident through his paintings *In the Teepee* (pl. 37) and *Canadian* [Cree] *Indians and Artist* (pl. 38). In the latter, Rindisbacher has painted himself enjoying a ceremonial round of the pipe of peace within the confines of the tepee; the artist makes clear that winter has come by including snowshoes and a leafless branch seen through the tepee doorway. A quotation from an 1829 article illustrated with a similar image describes the scene: "With the emblem of peace in my mouth, and seated by the generous chief, and receiving from all around me looks of kindness, it is not easy to conceive the extent of my feelings of joy and gratitude. . . ."[52]

In 1833, a year after Catlin's first steamboat voyage up the Missouri River, another Swiss artist, Karl Bodmer, steamed up the Missouri on the *Yellowstone,* traveling with his employer, Prince Maximilian of Wied-Neuwied. They made excursions at Fort Pierre (in what is now central South Dakota), Fort Clark (in central North Dakota), and Fort Union (on the North Dakota and Montana border) on their way to Fort McKenzie (at the confluence of the Missouri and Marias rivers in north central Montana). Fort McKenzie was the western terminus of their expedition, where they spent five weeks. On their return that year, they wintered at Fort Clark, where they spent time with the Arikara, Hidatsa, and Mandan peoples. Maximilian and Bodmer returned to Europe in 1834 and never came back to America. Maximilian published his *Travels in the Interior of North America* from 1839 to 1843, featuring more than eighty hand-colored engravings based on Karl Bodmer's paintings.

Bodmer made a number of studies of the Mandans while encamped at Fort Clark during the winter of 1833–34. The Mandans lived in earthen lodges and also protected their horses and dogs in the wood-beamed structures. *Interior of the Hut of a Mandan Chief* (pl. 39) reveals a comfortable dwelling with a fire in the center below a hole in the ceiling that allows light to enter and smoke to escape. Within

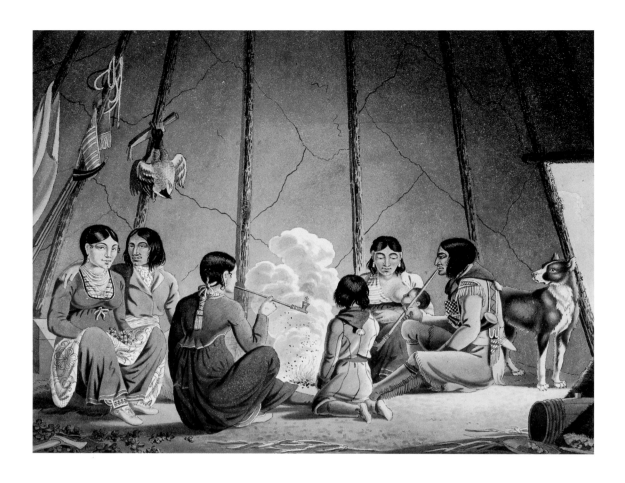

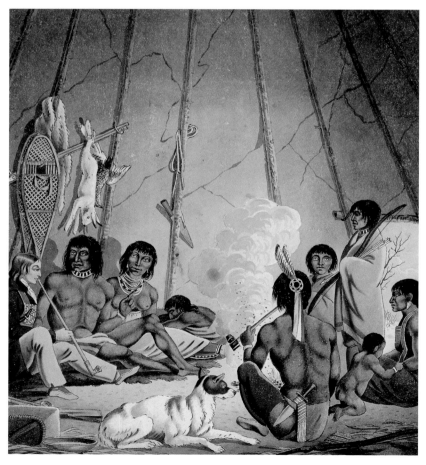

Peter Rindisbacher

37 *In the Teepee*

Undated, pen, ink, and watercolor on paper, 7⅛ × 9 in. (0226.1342)

Peter Rindisbacher

38 *Canadian [Cree] Indians and Artist*

Undated, watercolor on paper, 8 × 7 in. (0226.1341)

the pleasant confines are the central group of Mandans, portrayed at the beginning of a pipe ceremony, surrounded by dogs and with horses and food-gathering apparatus on the left and hunting and battle gear on the right.

In the same year (1834), George Catlin struck out with Colonel Henry Dodge's dragoons from Fort Gibson, Indian Territory (Oklahoma), heading generally southwest to the Red River and then up the North Fork of the Red River before returning via the same route. The artist's work resulting from the journey included *Village of the Pawnee Picts at the Base of the Rocky Mountains, Western Texas* [Wichita Village in Indian Territory at the Base of the Wichita Mountains] (pl. 40) and a more detailed scene of family life in *A Pawnee Pict Wigwam and Family in Western Texas* [Western Oklahoma] (pl. 41). The Pawnee Picts are what Catlin called the Wichita Nation. Historically prosperous through hunting, farming, and trading, the Wichita communities of grass lodges stretched from the Arkansas River to the Red River, an area including parts of Kansas, Oklahoma, and Texas. Catlin wrote: "To our very great surprise we found these people cultivating quite extensive fields of corn, pumpkins, melons, beans and squashes. So with these aids and an abundant supply of buffalo meat they may be said to be living well. / We found here a very numerous village containing some five or six hundred wigwams, all made of long prairie grass thatched over poles which are fastened in the ground and bent in at the tip, giving to them, in distance, the appearance of straw bee hives."[53]

KARL BODMER
39 *Interior of the Hut of a Mandan Chief*
Undated, ink, wash, and gouache on paper, 11 × 16 in. (0276.1742)

George Catlin

40 *Village of the Pawnee Picts at the Base
of the Rocky Mountains, Western Texas*
[Wichita Village in Indian Territory at
the Base of the Wichita Mountains]
1852, oil on canvas, 11⅛ × 14⅝ in. (0176.2124)

George Catlin was influential in Paul Kane's career choice—painting portraits of Indians and the landscape of the Canadian West. Born in Ireland, at age eight Paul Kane (1810–1871) was in Canada, and he was studying art by age twenty; at age thirty-one, while on a European study trip, he met Catlin in London. He learned that Catlin had sketched and painted Indian portraits, lifeways, customs, and western scenes in the United States. Kane determined to paint the Indians of Canada. For two-and-a-half years, between 1846 and 1848, Kane made his way across Canada from Toronto to Vancouver and back, traveling either by himself or with Hudson's Bay Company traders. He made more than five hundred sketches, watercolors, and oil studies during his journeys, leaving an unmatched legacy of western Canadian Indians and landscape in midcentury. His route was through the Red River Colony on the Winnipeg River in Manitoba into the high plains of the Saskatchewan, across the Rocky Mountains, down to the Columbia River, and up to Puget Sound and Vancouver Island. Returning to Toronto, he completed one hundred canvases by 1856. "More fortunate than Catlin, he sold the 100 canvases to a patron. Substantially all of his work including the simplest sketch remains in museum collections."[54] He completed *Sault Saint Marie—American Side* [Michigan] (pl. 42) in 1846, picturing

GEORGE CATLIN

41 *A Pawnee Pict Wigwam and Family in Western Texas* [Western Oklahoma]

1852, oil on canvas, 11⅛ × 14⅝ in. (0176.2161)

PAUL KANE

42 *Sault Saint Marie—American Side* [Michigan]

1846, oil on canvas, 18 × 30 in. (0126.1158)

wigwams of Ojibwas.[55] He published his journals in 1859, and they were subsequently published in Dutch, German, and French editions. He continued to paint until he lost his sight in 1866.[56]

Kane and Catlin were civilians, but some of the artists of the West had military careers. Like Seth Eastman—but twelve years later, in 1841—Alfred Sully (1821–1879) graduated from West Point. Rather than follow his famous portraitist father, Thomas Sully, and earn his living as an artist, Alfred Sully decided on a military career—but he was seldom without a sketchbook. He served in Florida during the Seminole wars, in the Mexican War, in Indian campaigns near the California/Oregon border, in the northern Plains Indian wars, in Virginia during the Civil War, and in the Northwest Indian campaigns. He became superintendent of Indians for Montana Territory in 1869, served in the Nez Perce war, and then served as post commander at Fort Vancouver in Washington Territory. His paintings *Indians Spearing Salmon* (pl. 43) and *Indian Maidens* (pl. 44) were made during his final years in the Northwest.[57]

Another painter of Indian life, and an explorer as well as an artist, John Mix Stanley started his art career as a portrait painter and later accompanied several expeditions to the West in the 1840s and 1850s. Stanley's penchant for mixing romanticism and realism in the same painting made his work popular; Millard Fillmore (U.S. president, 1850–53) owned one of his paintings.[58]

On each occasion John Mix Stanley traveled to the West, his goal was to sketch and make paintings of the Indian people he encountered. Stanley traveled to Fort Snelling (in Minnesota) in 1839 and to Fort Gibson, Indian Territory, from 1842 to 1845, where he established a studio to paint Native American portraits and

ALFRED SULLY

43 *Indian Spearing Salmon*

Undated, oil on canvas, 15⅛ × 20⅛ in.
(0126.1101)

ALFRED SULLY

44 *Indian Maidens*

Undated, oil on canvas, 17 × 22½ in.
(0126.1100)

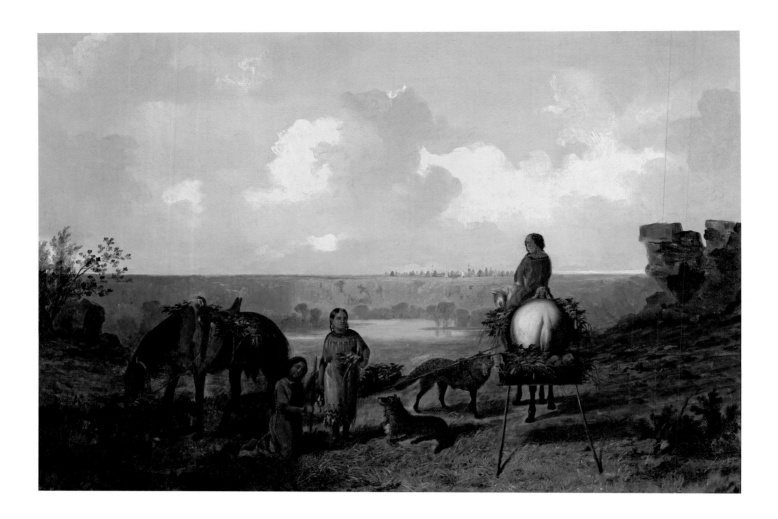

John Mix Stanley

45 *Tepia Gatherers*

c. 1853, oil on canvas, 21 × 30½ in.
(0126.1142)

scenes. (Catlin had spent time at Fort Gibson in 1834.) In June 1843 in Tahlequah (Oklahoma), Stanley was witness to the Grand Council called by the Cherokee leader John Ross, where several thousand Indians from throughout Indian Territory were present. On later occasions Stanley would travel the Santa Fe Trail (1846), chronicle the Mexican War in California as a staff artist for Colonel Stephen Kearny (1846), and join the Isaac Stevens expedition (1853–54) of the Army Corps of Topographical Engineers to search for a transcontinental railroad route across the Great Plains and northern Rocky Mountain region from Fort Snelling to Fort Vancouver (Washington, at the Columbia River, north of Portland, Oregon). Throughout it all, he would make sketches and paintings of all he encountered; he would later use them in creating paintings in his Detroit studio of scenes such as *Tepia Gatherers* (pl. 45) and *Game of Chance* (pl. 46).

Stanley's plan was to complete "the most comprehensive and descriptive of the subject [Indian tribes], of any that has been published."[59] Of Stanley's work, Seth Eastman commented: "I consider the artistic merits of yours far superior to Mr. Catlin's; and they give a better idea of the Indian, than any works in Mr. Catlin's Gallery."[60] Stanley's plan also called for the purchase of the paintings by the government. Unfortunately, on January 24, 1865, while he had more than two hundred stored at the Smithsonian Institution for purchase consideration, the building was gutted in a fire. George Catlin's stored paintings were also destroyed in the same conflagration.

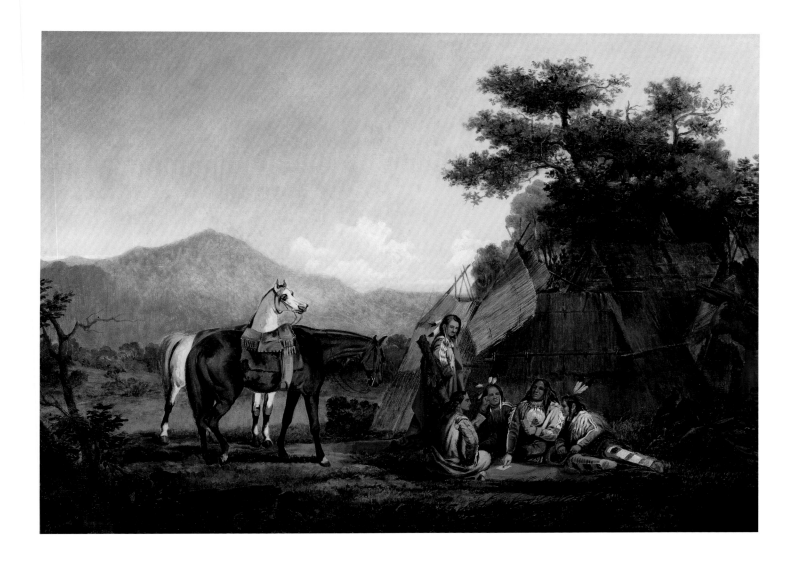

Catlin was approached by Henry Rowe Schoolcraft to serve as illustrator for his definitive study of Indians, but Catlin rejected the offer. Henry Schoolcraft was the husband of an Ojibwa, and he became an Indian agent at Sault Sainte Marie in 1821. He later became superintendent of Indian Affairs in Michigan Territory. Schoolcraft developed an interest in exploration and Indian ethnology and resided for "thirty years with the Indian tribes on the American frontiers."[61]

In 1847 Schoolcraft was commissioned by the government to fulfill an act of Congress to compile information and statistics about American Indians. Although he was able to generally gather information at will and receive complete cooperation, especially from government entities, he was not able to get George Catlin to provide images to use as illustrations. Catlin, after all, had submitted his paintings to Congress several times for their purchase consideration and was refused each time. Schoolcraft turned to Seth Eastman, whose work was more focused on the subject of genre and Indian family life. Catlin was a sociologist, ethnologist, and artist whereas Eastman was a soldier and artist/illustrator.[62] In the end, Schoolcraft was able to gather a mountain of information, including biographies of chiefs, Indian language vocabularies, legends, histories, customs, origin and emigration theories, and more than three hundred illustrations by such artists as John Mix Stanley and Seth Eastman.

JOHN MIX STANLEY
46 *Game of Chance*

1853, oil on canvas, 27½ × 38⅝ in.
(0126.1137)

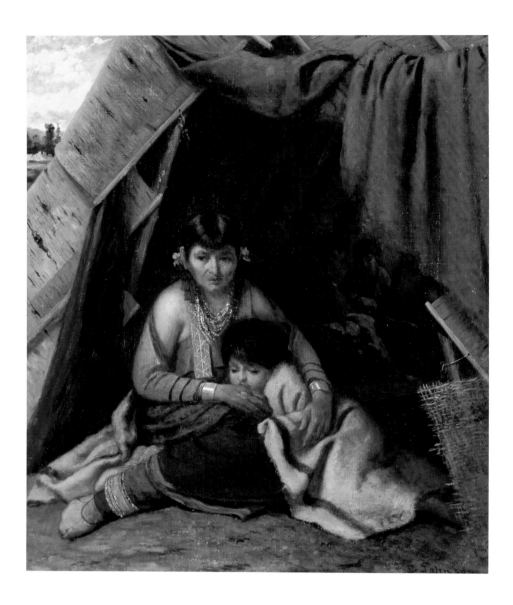

EASTMAN JOHNSON
47 *Indian Mother*

Undated, oil on canvas, 16¾ × 13½ in.
(0126.1507)

Like so many other American artists of the nineteenth century, Eastman Johnson (1824–1906), after an early career in portraiture, went to Europe to study painting technique. Returning to the United States after studying in Düsseldorf (Germany) and The Hague (Netherlands) from 1849 to 1855, Johnson settled in New York and established himself as a painter of scenes of family life. The artist made two trips in 1856 and 1857 to the town of Superior, Wisconsin, at the southwestern tip of Lake Superior. Those experiences resulted in a group of paintings on the subject of the natives of northeastern Minnesota, the Ojibwas. Among his first paintings of domestic subjects were *Indian Mother* (pl. 47) and *Portrait of an Indian Family* (pl. 48). The mat-covered wigwam plays an important role in both paintings. But also in the two paintings, Johnson adds the trappings that contact with white settlers made on the Ojibwa culture, including a log-and-plank house, a chair, the man's eastern-style clothing, and Hudson's Bay Company trade blankets. The faces of the subjects are revealing. In the last twenty-five years of his life, Johnson gave up genre painting for a highly successful career as a portrait painter.[63]

The Swiss national Rudolph Kurz's one overriding desire was to travel to America to sketch Indians. But he first took the advice of Karl Bodmer to improve

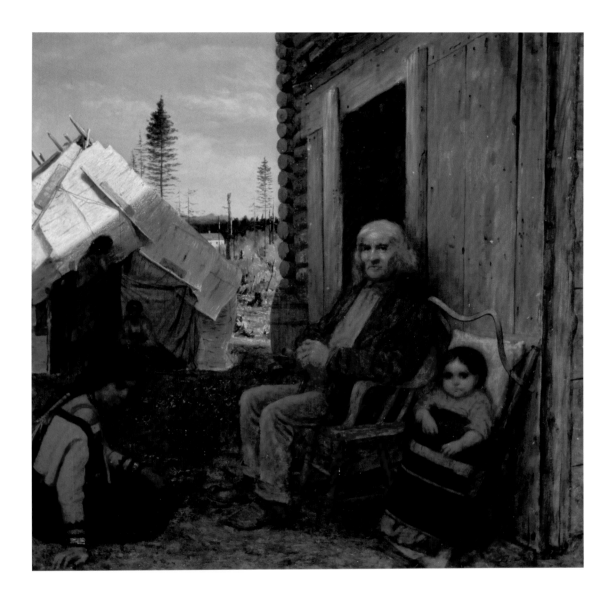

his drawing skills before making the trip. By the time he was twenty-nine, he had spent twelve years in German and French art academies, and some of the figures in his drawings and paintings take on the form of idealized studio models.

Kurz arrived in New Orleans in 1846 and went on to Saint Louis, where he set out the following year to sketch in Indian Territory (Oklahoma). He moved to Saint Joseph, Missouri, in 1848 to work at the Indian trading center, and in 1851 he steamed up the Missouri River to the frontier to serve as a clerk with the American Fur Company. At Fort Berthold, Fort Clark, and Fort Union he sketched both the Mandans and the Crows. He returned to Bern, Switzerland, in 1852 to paint and teach drawing. It is apparent that he only sketched what he personally experienced. He seldom converted his sketches into paintings—*Indians and Horses Crossing a River* (pl. 49) is one of a scarce group of paintings by the Swiss artist. He saw the scene through a telescope, and he described it in his journal on October 7, 1851:

> For a moment there arose such an unusual noise made by Indian women and children at the rear gate [of Fort Union] . . . by the sight of an Indian with his wife getting ready to swim with their two horses across the Missouri. . . . With

EASTMAN JOHNSON
48 *Portrait of an Indian Family*

Undated, oil on canvas, 23½ × 23½ in. (0126.1506)

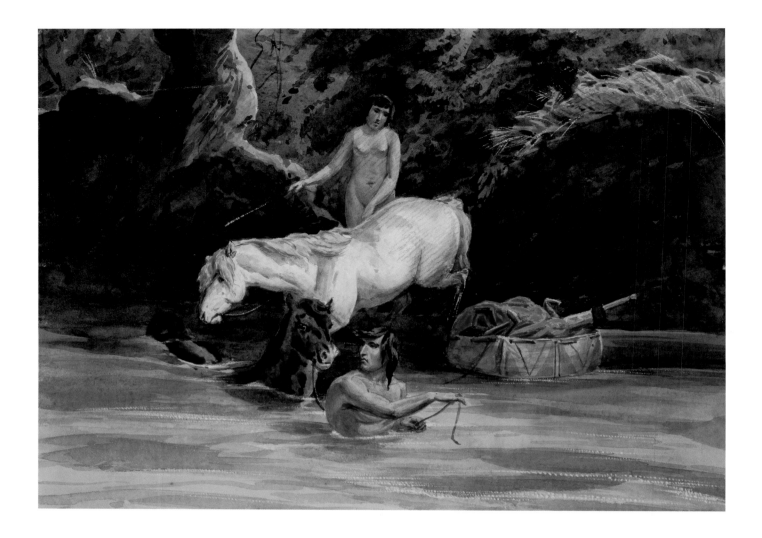

RUDOLPH F. KURZ

49 *Indians and Horses Crossing a River*

Undated, watercolor on paper,
9¾ × 12⅞ in. (0226.1344)

the aid of my telescope, I was enabled to watch his interesting preparations. . . . By means of a dried buffalo hide they formed a sort of flatboat on which they placed the saddles and their personal belongings and to which they fastened a long cord. . . . [H]is woman, screened by her own nag, stripped herself naked and, driving the horse before her to the river brink, gave over her clothes to her husband, who thrust them beneath her goods and chattels. Then, with powerful strokes, he started over, holding between his teeth his horse's lariat and the long cord with which he pulled the boat after him. His wife followed, guiding her nag in the same manner. They reached the shore on this side without the least trouble. For the sake of keeping on good terms with my bourgeois [storekeeper] I began to paint another female figure, but not entirely in the nude.[64]

Kurz was pleased when in the company of Indians; according to his journal entry on June 4, 1850: "I am living at the present in a trading house; I sleep on a buffalo robe; I am again in the midst of Indians who are continually trading [for] . . . gunpowder, lead and tobacco on credit that they may be prepared for hunting during the summer." The artist also took a great deal of interest in the look of the land, writing on May 8, 1851: "On the whole, the shores of the Missouri River reveal little that is picturesque [though other artists found great beauty in the region].

Even so, just the realization that this is Indian domain gives me a pleasurable interest in all scenes along the mighty stream."[65]

Rudolph Kurz was from Switzerland, but another European who had an impact on the art of the West was Henry Warre (1819–1898), a British military officer who made some of the first watercolors of the Pacific Northwest cultural region. In 1845 Captain Warre was sent on an undercover expedition to study American defensive capabilities during the Oregon Country border dispute between England and the United States. After reaching Fort Vancouver, Oregon Country, he and a companion officer traveled south through Willamette Valley and then turned back north to the Columbia River Gorge and thence across the Puget Sound region to Vancouver Island. On their return to England in 1846, they learned that the controversy had been settled by treaty. During his clandestine operations in the Oregon Country, Warre made almost one hundred watercolor paintings. Since the paintings were of no use to his government, Warre published twenty of them as lithographs two years later in *Sketches in North America and the Oregon Country*.[66] Included was the hand-colored lithograph "Indian Tomb" (pl. 50), which was published on the same page as an image of Fort Vancouver.

In 1852, four years after Henry Warre published his scenes of the Pacific Northwest, Mary Eastman published *The American Aboriginal Portfolio*, presenting twenty-six steel-engraved plates of her husband Seth Eastman's paintings of the

After HENRY J. WARRE

50 "Indian Tomb"

Hand-colored lithograph, 7½ × 11⅝ in., in *Sketches in North America and the Oregon Territory,* 1848 (2176.1014)

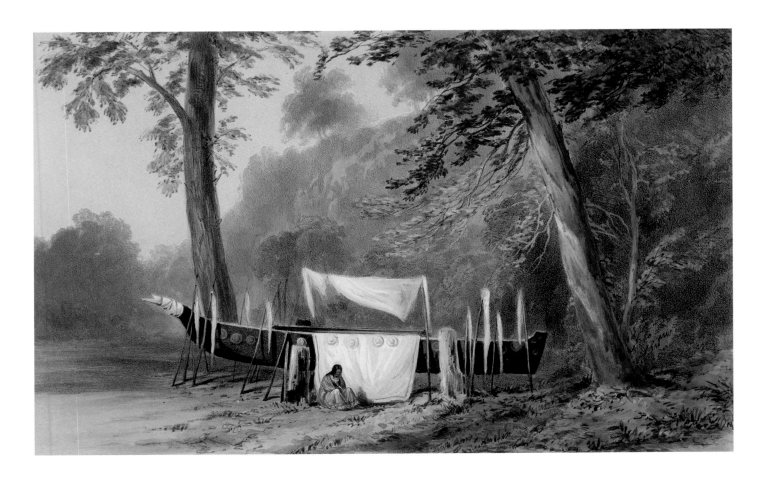

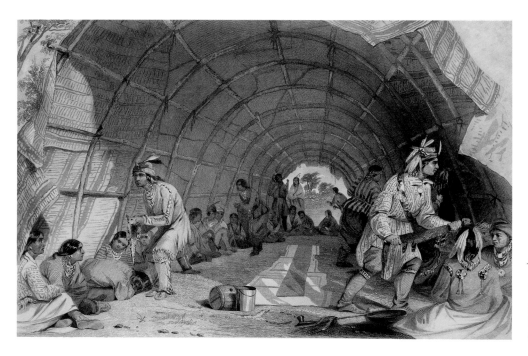

After SETH EASTMAN

51 "Medicine-Dance of the Winnebagoes"

Engraving, 6 × 9⅛ in., in Mary Eastman, *The American Aboriginal Portfolio,* 1852 (2126.1798)

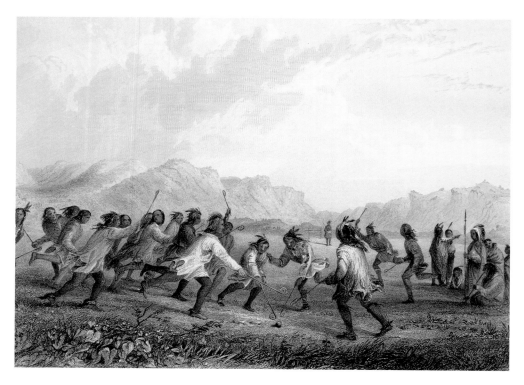

After SETH EASTMAN

52 "Ball Play on the Prairie"

Engraving, 9¼ × 12 in., in Henry R. Schoolcraft, *Information Respecting the History, Condition, and Prospects of the Indian Tribes of the United States,* part 2, 1852 (3736.305)

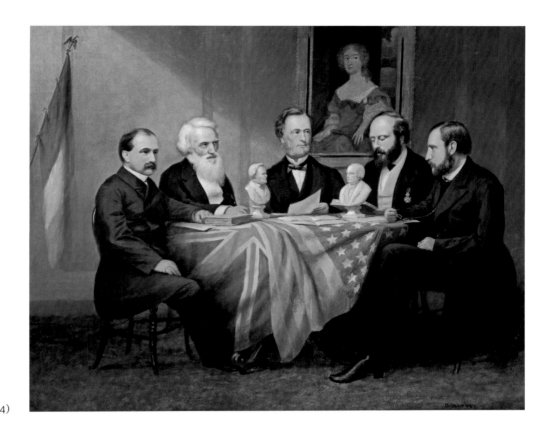

GEORGE HARVEY

53 *The Committee on the*
International Telegraph
in Paris

1867, oil on canvas, 16 × 21 in. (0176.1214)

Indian cultures of the northwestern woodlands and northeastern plains, including "Medicine-Dance of the Winnebagoes" (pl. 51).[67] Many of the same images from that publication were used by cultural historian Henry Rowe Schoolcraft in the six volumes of his *Information Respecting the History, Condition, and Prospects of the Indian Tribes of the United States.* One of them is "Ball Play on the Prairie" (pl. 52).

The American West changed—as did the East—when American industry swept through with life-altering technological inventions. Artists documented the events. One of the remarkable technological achievements was the October 1861 completion of the stringing of transcontinental telegraph lines by Western Union, putting an end to the Pony Express, which had started operations in April 1860. The electromagnetic telegraph had been invented in the 1830s, and the first telegraph line was completed in 1844 between Baltimore and Washington, D.C.

Artist George Harvey (1800–1878), born and trained in England but with experience in the American West, noted the importance to worldwide communication of the electromagnetic telegraph by painting *The Committee on the International Telegraph in Paris* (pl. 53). The telegraph had an encouraging effect on the settlement of the West. The committee members in Harvey's painting are identified on the back simply as "Prof. Frazer, W. J. Valentine, Pres. Bernard, Prof. Samuel F. B. Morse [inventor of the telegraph and Morse code], Col. Norton of Columbia College."

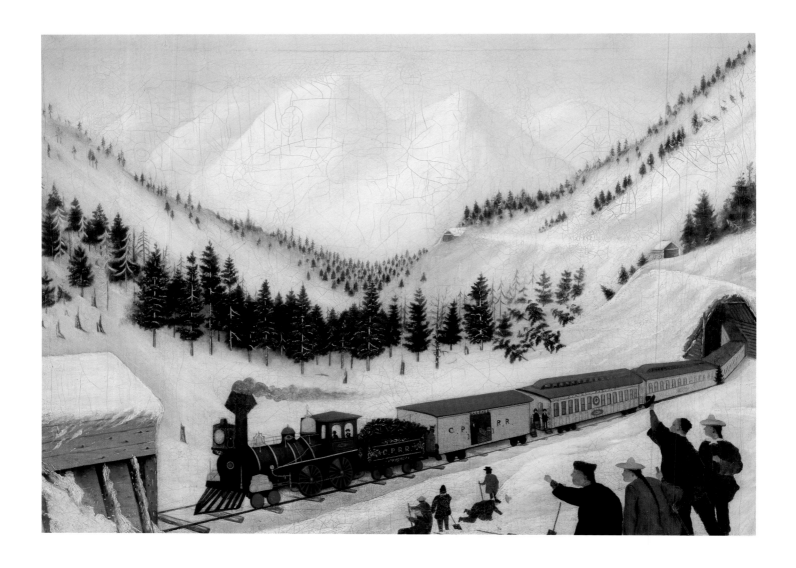

JOSEPH BECKER

54 *Snow Sheds on the Central Pacific Railroad in the Sierra Nevada Mountains*

Undated, oil on canvas, 19 × 26 in. (0136.1212)

The year before the first telegraph line was completed across the trans-Mississippi West, the last of four transcontinental railroad survey reports was submitted to the United States Congress. In 1853 Congress funded the four surveys to find the best routes to the Pacific coast—one northern, two central, and one southern route. The final reports to Congress were released via thirteen volumes (with illustrations) over a five-year period, 1855 to 1860. By the end of the nineteenth century, all of the proposed routes were in operation. However, the first route was not one of the four original proposals; instead a private company established the Central Pacific Railroad Company of California in 1861 and, beginning from Sacramento in February 1863, laid the first tracks over and through the difficult terrain of the Sierra Nevada Mountains to Nevada and thence to Utah.

America and its new nineteenth-century technologies and industries were bolstered by the completion of the transcontinental railroad to California. Joseph Becker (1841–1910) learned to sketch while working at *Leslie's Illustrated* in New York City. His first work for that newspaper was sketching Civil War scenes in the field. In October 1869 he took the first cross-continental Pullman train from Omaha to

San Francisco. The transcontinental line was completed earlier the same year, on May 10, when the rails and trains of the Union Pacific and Central Pacific railroads met at Promontory Point, Utah, near the northeast sector of the Great Salt Lake. Becker's trip took eighty-one hours.[68] *Leslie's* published forty of his illustrations from the trip. Becker's oil painting *Snow Sheds on the Central Pacific Railroad in the Sierra Nevada Mountains* (pl. 54) was no doubt inspired by his train experiences and his studies of the Chinese who had worked as laborers during the construction of the railroad.

Chinese railroad workers were responsible for laying most of the track for the western portion of the transcontinental railroad, the Central Pacific. By 1867 some 12,000 workers—90 percent of the labor force—on the Central Pacific were Chinese. In 1868 the Union Pacific "laid 425 miles of track, while the CP bored 15 tunnels and built 360 miles of [rail]road."[69] Becker spent six weeks making studies of Chinese laborers, and he paid homage to their hard work by including them in his painting.

Emanuel Leutze was also interested in depicting the value of the labors of men and women for the good of others. Leutze traveled cross-country to California in 1861, producing sketches and studies to use on return to his studio. The purpose of the trip was to gather information for his commission to paint a monumental work for the United States Capitol on the subject of settlement in the far West. The commission was given on July 9, 1861, proclaiming "that Mr. Leutze shall paint upon the western wall of the western stairs of the Capitol extension a picture of emigration, size including ornamental border to be twenty by thirty feet, to be finished within two years from date, and that for this work Mr. Leutze shall be paid by the United States, a sum total of $20,000 [equivalent to $411,000 today]. . . . "[70] Leutze was already known to Congress for other work, and he was commended as "an enthusiastic believer in American principles."[71] A study for the painting, *Westward the Course of Empire Takes Its Way* (pl. 55), is in the Gilcrease collection. It takes its title from a poem written by Irish Bishop George Berkley (1685–1753), an early eighteenth-century visitor to the United States: "On the Prospect of Planting Arts and Learning in America: Westward the Course of Empire Takes Its Way; / The four first acts already past, / a fifth shall close the drama of the day; / Times noblest offspring is the last."[72] A symbol of the United States, an eagle with an olive branch, presides over the scene from the top, suggesting that the lands settled will become new states. The small images in the circles on right and left represent scenes of exploration. In keeping with that theme, at the bottom of the painting are images of William Clark (left) and Daniel Boone (right), flanking San Francisco Bay, the central Pacific Coast terminus of the American West.

Leutze's painting was about expansion and settlement, and expansionist policies were seen at work in many wars. During the American Revolution, supporters of the British cause, both Indians and Tories, attacked American settlements. In late 1778, after failing in their attempts to attack American forts, Indians and Tory rangers, under command of Mohawk leader Joseph Brant (Thayendanegea) and Loyalist Major William Butler, attacked American settlements like Cherry Valley in Otsego County, New York, where they killed the entire Wells family in their home. Peter

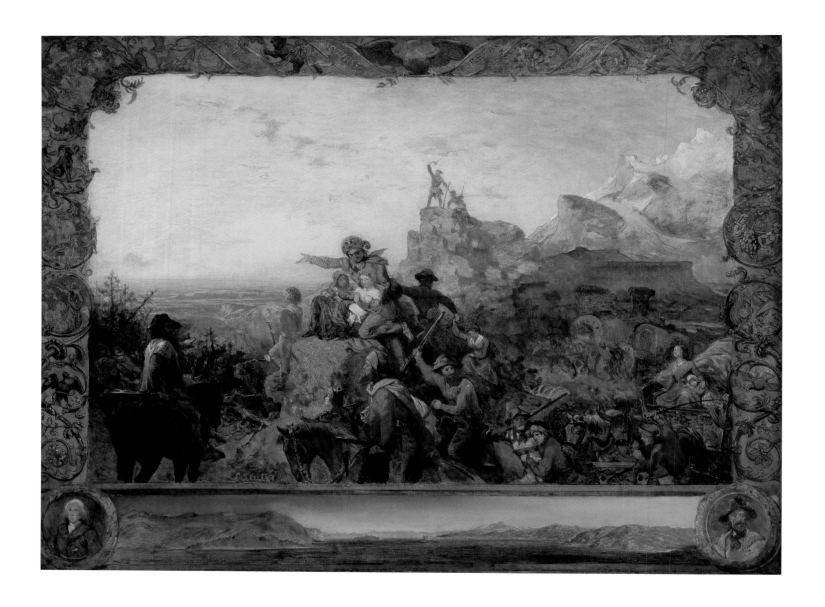

EMANUEL LEUTZE

55 *Westward the Course of Empire Takes Its Way*

c. 1861, oil on canvas, 30 × 40 in.
(0126.1615)

Smith, a Tory, had known Jane Wells by his service in her household; he attempted to defend her but to no avail, as pictured in the 1856 painting by Alonzo Chappel (1828–1887), *The Fate of Jane Wells* (pl. 56). The settlement was completely destroyed in the attack, and afterward the survivors abandoned it. Chappel was a painter and illustrator of historical subjects who, like many others, began his career as a portrait painter. He was born in New York City and worked creating illustrations of historical subjects for publication.

Bavarian-born Johannes Simon Oertel's (1823–1909) goal as a youth was to become a missionary, but instead he became enthralled with art and understudied with a Munich engraver. After immigrating to the United States in 1848, he established a life as an artist and teacher and became known mostly as a painter of religious imagery. His earliest scenes of Indians were done for bank note engravings. In the late 1850s, he made designs for the ceiling in the House of Representatives. He continued to paint and teach after becoming a minister in 1871.[73] *The Marauders*

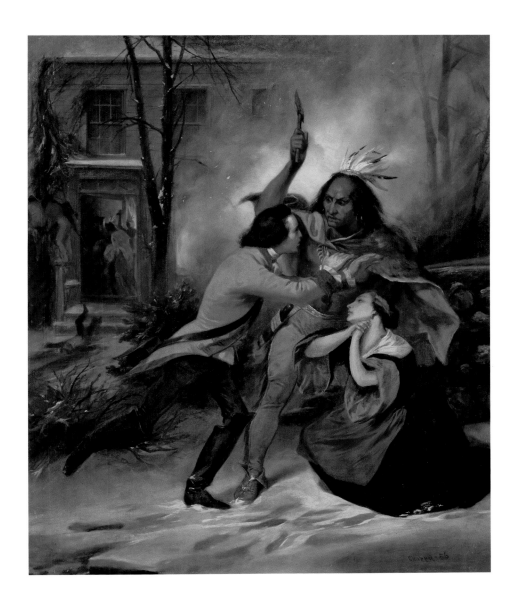

(pl. 57) portrays a group of three Indian raiders with a captive horse. Oertel probably never saw the Great Plains or the Indians he painted, who are similar to some of the portraits in McKenney and Hall's book. Painted in 1860, the landscape is flat and the Indian "ponies" are too large for the mustangs used by the horse culture of the plains. The horses resemble the type painted by Arthur Tait (1819–1905), whose lithographs of trappers (and their horses) were widely distributed by Currier and Ives in the 1850s. Tait was born in England and settled in New York in 1850. He never traveled to the West, but his friendship with William Ranney, a fellow painter who specialized in western scenes, sparked his interest in paintings based on the theme of mountain men in dramatic scenes of action. *The Check* (pl. 58) is one of a number of paintings he created that were used by Currier and Ives. The nineteenth-century lithographic firm had a workshop of artists who added color by hand painting the black-and-white prints, a common practice before the widespread use of chromolithography later in the century.

ALONZO CHAPPEL
56 *The Fate of Jane Wells*

1856, oil on canvas, 27 × 22 in. (0126.1651)

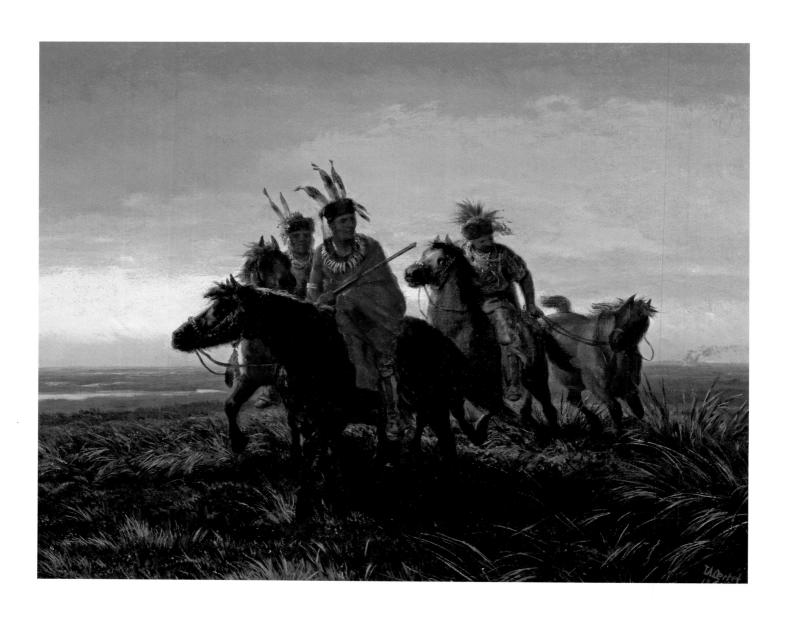

JOHANNES SIMON OERTEL
57 *The Marauders*
1860, oil on canvas, 16 × 20 in. (0126.1640)

Arthur F. Tait

58 *The Check*

1854, oil on canvas, 30 × 44 in. (0126.1159)

EMANUEL LEUTZE
59 *Indians and Captive*

Undated, oil on canvas, 16 × 24½ in.
(0126.1614)

Tait was finishing his series of paintings depicting trapper scenes for Currier and Ives at essentially the same time that Leutze was beginning work on the immigration scene for the U.S. Capitol. Leutze also painted other imagined images of Indians, such as one entitled *Indians and Captive* (pl. 59), which speaks of the clash between the cultures.

In contrast to these imagined images, Alvan Fisher's (1792–1863) painting *The Escape of Major McCulloch* (pl. 60) was based on a true event. In September 1777, during the Revolutionary War, the Shawnees (acting on behalf of the British) attacked Fort Henry near Wheeling, West Virginia. Major Samuel McCulloch arrived with reinforcements but became cut off from his men by the attackers. He escaped pursuit by riding his horse down a steep two-hundred-foot escarpment and across Wheeling Creek to safety. The Indians are shown without horses and apparently unable to pursue the major. The story of McCulloch's real-life escape became legend, and the place is now known as McCulloch's Leap. The attackers withdrew after burning the settlement but not the fort. No defenders were killed.[74]

Interest in depictions of Indian life and illustrations of stories involving Indian people diminished during the Civil War in favor of paintings and illustrations of Civil War battles. Epic battles on land and water, and tide-changing battles such as

that fought between the battleships *Monitor* and *Merrimack,* were well read and well pictured. The story of the confrontation between the first two iron battleships is well known, but less known is the engagement that preceded the conflict by a day. On March 8, 1862, the CSS *Virginia* (formerly the USS *Merrimack*) steamed north from Norfolk, Virginia, across Hampton Roads (at the mouth of the James River, west of the entrance to Chesapeake Bay). Then the *Merrimack* single-handedly attacked the wooden ships of the Union fleet in Hampton Roads, running USS *Congress* aground and destroying her with cannon shot, sinking the USS *Cumberland* by ramming her, and destroying three Union transport vessels before returning to port. The Union lost more than one hundred and twenty *Cumberland* crewmen that day. The *Cumberland* engagement, with *Congress* burning in the background, is

ALVAN FISHER

60 *The Escape of Major McCulloch*

c. 1840s, oil on canvas, 36 × 42 in. (0162.1160)

Attributed to ALEXANDER STUART

61 *The Attack of the Merrimack on Union Naval Vessels*

Undated, oil on canvas, 30 × 50 in. (0116.1559)

vividly portrayed in a painting by Alexander Stuart (1831–1898), *The Attack of the Merrimack on Union Naval Vessels* (pl. 61). The next morning, the *Merrimack,* while steaming under intention to sink the USS *Minnesota,* met the USS *Monitor,* the first iron vessel of the Union, in a head-to-head close-range duel of the first iron-armored warships. Although shaped and sized differently, the ships were equally matched, and the battle resulted in a draw. The CSS *Virginia* had been built on the hull of a salvaged Union vessel, the USS *Merrimack,* and was modified with iron siding over the wood and armed with ten rifled heavy guns. However, the *Monitor* was built of all iron, including the rotating gun turret, the first of its kind. The *Monitor* was half the size of *Merrimack* and had only two smooth-bore heavy guns in the turret, but it was faster. Circumstances caused both ships to retire from the battle.

After the Civil War, with so many battles won and lost and so many hundreds of thousands of deaths, the public lost interest in paintings of the Mexican and Civil wars. Just as the navy recognized the need to change from wooden sailing vessels to vessels of iron and steam, so too was it time for a different kind of art, one that moved from a focus on history painting (including the Indian subjects of the West) to an art of landscape with monumental, larger-than-life subjects of lofty mountains and deep canyons. The revealing works of Albert Bierstadt and Thomas Moran marked a turning point for art and the recession of the styles and subjects promulgated after Lewis and Clark's triumphant trek across the continent.

Albert Bierstadt was key to the portrayal of the western landscape in monumental painting. Born in Europe, he came to America as a boy and returned for a time to Germany to train at the Düsseldorf Art Academy, where he was taught the technique of dark and light tonal contrasts that appear in much of his painting.[75] His training also exposed him to the European tradition of placid scenes in perfect settings. He took the sensibilities of the European style, transposed it to the American West, and invented a new kind of western landscape whereby an overall effect was achieved and no part of the painting took visual precedence over another.

Albert Bierstadt's initial trip to the West was in 1859, and he first saw California and Oregon in 1863. *Multnomah Falls* [Oregon] (pl. 62) is a majestic scene of the waterfalls (some thirty miles east of Portland in the Columbia River Gorge) that drop six hundred and twenty feet in two cascades. The painting brings to light the natural autumnal glory of the region, and it features the hallmarks of the artist's style—glistening waterfalls and rapids, brilliant fall colors, misty daylight, and clouds drifting through space.

Bierstadt's style was short lived in America, perhaps because of its rather foreboding contrast, and in the 1870s it was eclipsed by the more ebullient and clever painting of Thomas Moran, who was himself influenced by a European painting style unique to British artist Joseph M. W. Turner (1775–1851).[76] Many of Moran's western paintings were bathed with light and color, brilliance often overshadowing contrast. Composing paintings from on-the-spot sketches and color notes, both Bierstadt and Moran rarely presented a literal rendering of a subject but were nevertheless true to the sense of a place, never losing sight of its character.

Although born in England, Thomas Moran came to the United States as a boy and was a thoroughly American painter. He learned some from his brother and was an apprentice to a wood engraver, but he was mostly self-taught as an artist. At age twenty-three he went to England, where he encountered the work of J. M. W. Turner and became enamored with effects of bright color, which he also studied during two visits to France and Italy.

Moran's first trip to the American West was to Yellowstone in 1871, followed by his first trip to the Grand Canyon in 1873. Just as Lewis and Clark's Corps of Discovery marked the beginning of the nation's expansion west of the Mississippi, so too did Moran's 1871 trip with Ferdinand V. Hayden and the United States Geological Survey mark the beginnings of the national park system in 1872, after Congress saw Moran's paintings of Yellowstone. It was the manifestation of a new age in the influence of art. Moran saw the West as "grandeur, beauty, color, and light—nothing of man . . . but nature, virgin, unspoiled, and lovely."[77] Moran described his aesthetic approach:

> I place no value on literal transcripts from nature. My general scope is
> not realistic; all my tendencies are toward idealization. Of course, all art
> must come through Nature or naturalism. . . . the gorgeous display of color
> impressed itself upon me. . . . [W]hile I desired to tell truly of nature, I did
> not wish to realize the scene literally, but to preserve and convey its true

ALBERT BIERSTADT

62 *Multnomah Falls* [Oregon]

Undated, oil on canvas, 44¼ × 30⅜ in. (0126.2354)

THOMAS MORAN

63 *Side Canyon of the Colorado*
[River, Grand Canyon, Arizona]

1878, oil on canvas, 44¾ × 38¾ in. (0126.2345)

impression. Every form introduced into the picture is within view from a given point, but the relation of the separate parts to one another are not always preserved. . . . My aim was to bring before the public the character of that region.[78]

During Moran's expedition to the Grand Canyon in 1873 with John Wesley Powell, he may have seen a view similar to the one captured in *Side Canyon of the Colorado* [River, Grand Canyon, Arizona] (pl. 63). The tiny figures on the left highlight the immensity of the canyon. Light and contrast is revealed as shadows darken the canyon walls, and the cascading water and the distant sunlit cliffs of the Grand Canyon underscore the verticality of the subject.

Such paintings conveyed Thomas Jefferson's earlier dream of the United States stretching from sea to sea. As Lewis and Clark were in the first months of their journey up the Missouri River, Jefferson was eager to carry forward other planned explorations of the Louisiana Purchase. One such expedition was undertaken by Lawrence Dunbar to explore the southwestern boundaries of the Louisiana Purchase in 1804 and 1805. Jefferson wrote Dunbar on May 25, 1805, a little more than a year after Lewis and Clark departed on their journey of discovery. Jefferson's letter included a prophetic statement particularly applicable to artists, although he was speaking of the mapping of the West for future settlement: "The work we are now doing is done for posterity. . . . We shall delineate with correctness the great arteries of this great country; those who come after us will extend the ramifications as they become acquainted with them, and fill up the canvas we begin."[79]

The artists of the nineteenth-century American West filled up their canvases with scenes, events, and people that had never before been painted. Despite their training and expectations, they were forced to look with new eyes and to develop methods and styles of painting that were different from what had been done before. Their presence at the events and scenes and with the people they depicted was crucial to the delineation of the history and the aesthetic and mythic vision of the West. Their paintings are not mere reportage. These artists were interpreters of what they encountered, and through their works other artists and illustrators back East took greater interest in depicting Native Americans and western landscapes. Although exaggerations were inevitable, the artworks of the nineteenth-century American West can be better understood through the eyeglass of history, for this art is inseparable from the period in which it was made.

OPPOSITE:
Thomas Moran, *Side Canyon of the Colorado* [River, Grand Canyon, Arizona], 1878 (detail, pl. 63)

NOTES

1. William H. Goetzmann and Glyndar Williams, *The Atlas of North American Exploration: From the Norse Voyages to the Race to the Pole* (Norman: University of Oklahoma Press, 1992).

2. Reuben Gold Thwaites, ed., *Original Journals of the Lewis and Clark Expedition, 1804–1806* (New York: Dodd, Mead, 1904), 257, 284, 287.

3. Zebulon Pike, *An Account of Expedition to the Sources of the Mississippi and Through Western Parts of Louisiana . . . during the Years 1805, 1806, and 1807; and a Tour Through the Interior Parts of New Spain* (Philadelphia: C. & A. Conrad, 1810).

4. Peggy Samuels and Harold Samuels, *The Illustrated Biographical Encyclopedia of Artists of the American West* (Garden City, N.Y.: Doubleday, 1976), 434.

5. Ron Tyler, *Prints of the West: Prints from the Library of Congress* (Golden, Colo.: Fulcrum Publishing, 1994), 30.

6. Samuels and Samuels, *Artists of the American West,* 365.

7. Edwin James, *Account of an Expedition from Pittsburgh to the Rocky Mountains Performed in the Years 1819 and 1820, by Order of the Honorable J.C. Calhoun, Secretary of War, under the Command of Major Stephen H. Long* (Philadelphia: H.C. Carey and I. Lea, 1823).

8. Quoted in Bill Gilbert, *The Old West: The Trailblazers* (New York: Time-Life Books, 1973), 162.

9. Ibid.

10. Samuels and Samuels, *Artists of the American West,* 341.

11. Idaho State Historical Society Reference Series, http://www.idahohistory.net/reference_series.html (number 370).

12. Ibid., number 369.

13. From the transcript of the report quoted in Steven R. Butler, ed., *A Documentary History of the Mexican War* (Richardson, Tex.: Descendants of Mexican War Veterans, 1995), 108–114.

14. John C. Ewers, *Artists of the Old West* (New York: Doubleday, 1965), 16.

15. Ellen G. Miles, *Saint-Mémin and the Neoclassical Profile Portrait in America* (Washington, D.C.: National Portrait Gallery, Smithsonian Institution Press, 1994); for more information about Shahaka, refer to Tracy Potter, *Sheheke, Mandan Indian Diplomat: The Story of White Coyote, Thomas Jefferson, and Lewis and Clark* (Helena, Mont.: Farcountry Press, 2003).

16. James Otto Lewis, *Aboriginal Port Folio* (Philadelphia: James Otto Lewis, 1835–1836).

17. Ibid.

18. James D. Horan, *The McKenney-Hall Portrait Gallery of American Indians* (New York: Crown Publishers, 1972), 186.

19. Ibid., 274.

20. Herman J. Viola, *Thomas L. McKenney: Architect of America's Early Indian Policy, 1816–1830* (Chicago: Swallow Press, 1974).

21. T.C. McLuhan, *Touch the Earth: A Self-Portrait of Indian Existence* (New York: Promontory Press, reprinted by arrangement with Outerbridge & Dienstfrey, 1992), 61, 63.

22. William H. Truettner, *The Natural Man Observed: A Study of Catlin's Indian Gallery* (Washington, D.C.: Smithsonian Institution, 1979), 213.

23. George Catlin, *North American Indians: Being Letters and Notes on Their Manners, Customs, and Conditions, Written during Eight Years' Travel amongst the Wildest Tribes of Indians in North America, 1832–1839* (Edinburgh: John Grant, 1926), vol. 2, pp. 115–116.

24. Catlin quoted by Truettner, *Natural Man Observed,* 175.

25. Catlin, *North American Indians,* vol. 1, p. 217. Catlin reversed the labeling of plates 77 and 78: Ee-hee-a-duck-chee-a appears in plate 77.

26. Ibid., 4.

27. William H. Goetzmann, David C. Hunt, Marsha V. Gallagher, and William J. Orr, *Karl Bodmer's America* (Lincoln: Joslyn Art Museum and University of Nebraska Press, 1984), 132–133.

28. McLuhan, *Touch the Earth,* 143.

29. William H. Goetzmann and William N. Goetzmann, *The West of the Imagination* (New York: W.W. Norton, 1986), 63.

30. Ibid., 62.

31. Samuels and Samuels, *Artists of the American West,* 533.

32. William Kloss and Diane K. Skvarla, *United States Senate Catalogue of Fine Art* (Washington, D.C.: U.S. Government Printing Office, 2002), 128–129.

33. Mary Henderson Eastman, *Dahcotah; or, Life and Legends of the Sioux around Fort Snelling,* pref. by Rena Neumann Coen (Afton, Minn.: Afton Historical Society Press, 1995).

34. Richard Rhodes, *John James Audubon: The Making of an American* (New York: Alfred A. Knopf, 2004), 426.

35. John James Audubon and Rev. John Bachman, *The Viviparous Quadrupeds of North America,* 3 vols. (New York: J. J. Audubon, 1846, 1851, 1856).

36. Rhodes, *John James Audubon,* 219.

37. Ibid., 262.

38. Quoted in Ron Tyler, *Audubon's Great National Work: The Royal Octavo Edition of "Birds of America"* (Austin: University of Texas Press, 1993), 139.

39. "Icons: Faces of Heros," *Gilcrease Journal* 8, no. 1 (2001): 36.

40. Page Stegner, *Winning the Wild West: The Epic Saga of the American Frontier, 1800–1899* (New York: Free Press, 2002), 258.

41. Robert M. Utley, ed., *The Story of the West: A History of the American West and Its People* (New York: DK Publishing, 2003), 194.

42. Robert Taft, *Artists and Illustrators of the Old West: 1850–1900* (New York: Charles Scribner, 1953), 292–293; for more information on J. Ross Browne, refer to John Francis Rock, *J. Ross Browne: A Biography* (Washington, D.C.: Catholic University of America, 1929).

43. Quoted in Paul A. Rossi and David C. Hunt, *The Art of the Old West* (New York: Alfred A. Knopf, 1971), 121.

44. Ibid., 119.

45. Ron Tyler, ed., *Alfred Jacob Miller: Artist on the Oregon Trail* (Fort Worth: Amon Carter Museum, 1982), 21.

46. Marvin C. Ross, *The West of Alfred Jacob Miller (1837) from the Notes and Water Colors in the Walters Art Gallery* (Norman: University of Oklahoma Press, 1951), verso of p. 181, opposite p. 182.

47. Miller quoted in Tyler, *Alfred Jacob Miller,* description for pl. 101.

48. Ibid., description for pl. 59.

49. Goetzmann and Goetzmann, *West of the Imagination,* 63.

50. Ibid., 66.

51. For additional information about the life of Peter Rindisbacher, refer to Alvin M. Josephy Jr., *The Artist Was a Young Man: The Life Story of Peter Rindisbacher* (Fort Worth: Amon Carter Museum, 1970).

52. "The Sioux Chief," *The Casket: Flowers of Literature, Wit and Sentiment for 1829* (Philadelphia: Samuel C. Atkinson, 1829), 433.

53. George Catlin, *North American Indians,* vol. 2, p. 79.

54. Samuels and Samuels, *Artists of the American West,* 259.

55. Ibid., 258–259.

56. For additional information about the life of Paul Kane, refer to Paul Kane, *Paul Kane's Frontier: Including Wanderings of an Artist Among the Indians of North America,* ed. Harper J. Russell (Austin: University of Texas Press, 1971).

57. For additional information about the life of Alfred Sully, refer to Langdon Sully, *No Tears for the General: The Life of Alfred Sully, 1821–1879* (Palo Alto, Calif.: American West Publishing, 1974).

58. John Mix Stanley, *Portraits of North American Indians, with Sketches of Scenery, etc., Painted by J.M. Stanley, Deposited with the Smithsonian Institution* (Washington, D.C.: Smithsonian Institution, 1852).

59. Edwin Bryant, *What I Saw in California* (New York: D. Appleton, 1848), 436.

60. Quoted in Taft, *Artists and Illustrators of the Old West,* 13.

61. Henry Rowe Schoolcraft, *Personal Memoirs of a Residence of Thirty Years with the Indian Tribes on the American Frontiers* (New York: AMS Press, 1978), title page.

62. Henry Rowe Schoolcraft, *Information Respecting the History, Condition and Prospects of the Indian Tribes of the United States: Collected and Prepared Under the Direction of the Bureau of Indian Affairs, per Act of Congress of March 3rd, 1847,* 6 vols. (Philadelphia: Lippincott, Grambo, 1851–1857).

63. John I. H. Baur, *An American Genre Painter: Eastman Johnson, 1824–1906* (Brooklyn: Brooklyn Museum, 1940), 15–16; for additional information about the life of Eastman Johnson, refer to Patricia Condon Johnston, *Eastman Johnson's Lake Superior Indians* (Afton, Minn.: Johnston Publishing, 1983).

64. Rudolph Friederich Kurz, *Journals of Rudolph Friederich Kurz: An Account of His Experiences Among the Fur Traders and American Indians on the Mississippi and the Upper Missouri Rivers During the Years 1846 to 1852,* trans. Myrtis Jarrell, ed. J. N. B. Hewitt (Washington, D.C.: U.S. Government Printing Office, 1937), 167.

65. Ibid., 64, 333.

66. Henry James Warre, *Sketches in North America and the Oregon Country* (London: Dickenson, 1848).

67. Mary Henderson Eastman, *The American Aboriginal Portfolio* (Philadelphia: Lippincott, Grambo, 1853).

68. Samuels and Samuels, *Artists of the American West,* 33–34.

69. Utley, *Story of the West,* 228.

70. Charles Fineman, *Art and Artists of the Capitol of the United States of America* (Washington, D.C.: U.S. Government Printing Office, 1927), 202.

71. Ibid., 202.

72. Fred Myers et al., *Thomas Gilcrease and His National Treasure* (Tulsa: Gilcrease Museum, 1987), 44.

73. Samuels and Samuels, *Artists of the American West,* 350–351.

74. John W. Barber and Henry Howe, *Historical Collections of the State of New York* (New York: S. Tuttle, 1841); Christopher Ward, *The War of the Revolution* (New York: MacMillan, 1952), vol. 1, p. 852; Mark M. Boatner III, *The Encyclopedia of the American Revolution* (New York: D. McKay, 1966), 692, 1196.

75. For more information on Albert Bierstadt, refer to Nancy K. Anderson and Linda S. Ferber, *Albert Bierstadt: Art and Enterprise* (New York: Hudson Hills Press in association with the Brooklyn Museum, 1990).

76. For more information on Thomas Moran, refer to Nancy K. Anderson et al., *Thomas Moran* (Washington, D.C.: National Gallery of Art; New Haven: Yale University Press, 1997).

77. Thomas Moran papers, Gilcrease Museum, Tulsa.

78. G. W. Sheldon, *American Painters* (New York: D. Appleton, 1879), 125.

79. Thomas Jefferson to Lawrence Dunbar, May 25, 1805, Thomas Jefferson Papers Series 1, Library of Congress, accessed at "They Helped to Fill Up the 'Canvas,'" The Loc.gov Wise Guide, http://www.loc.gov/wiseguide/oct03/lewisclark.html.

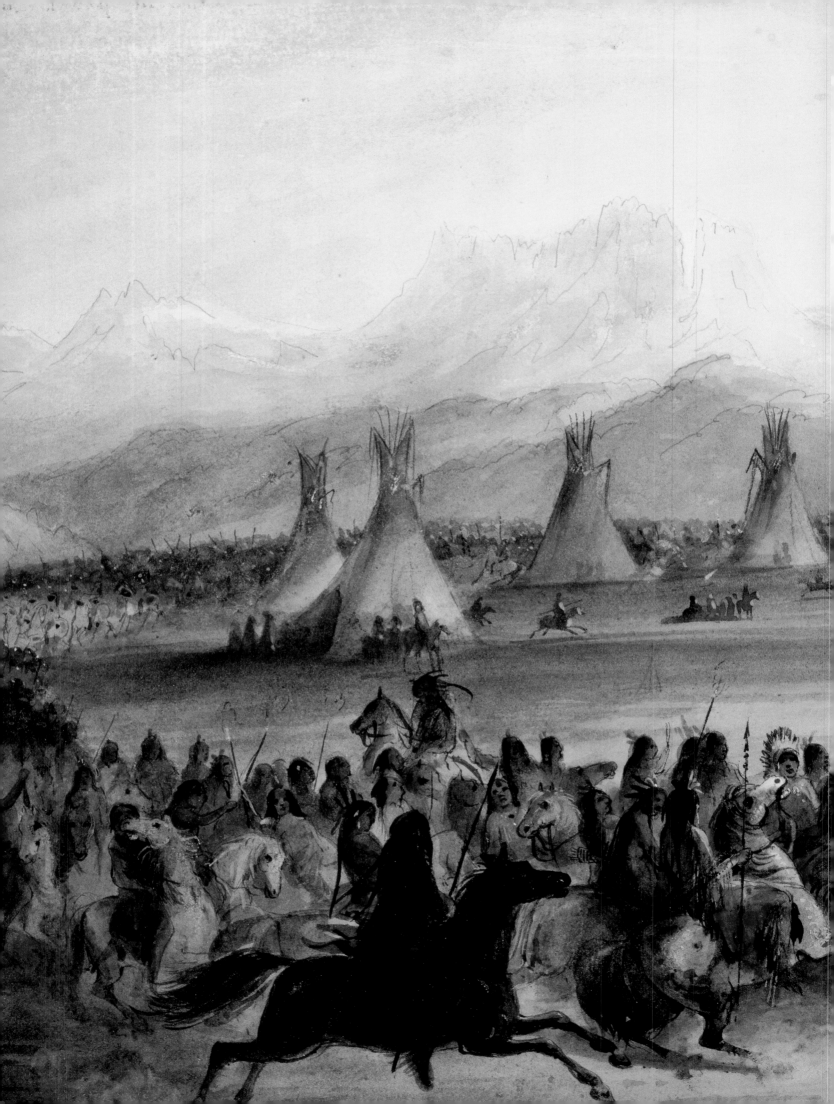

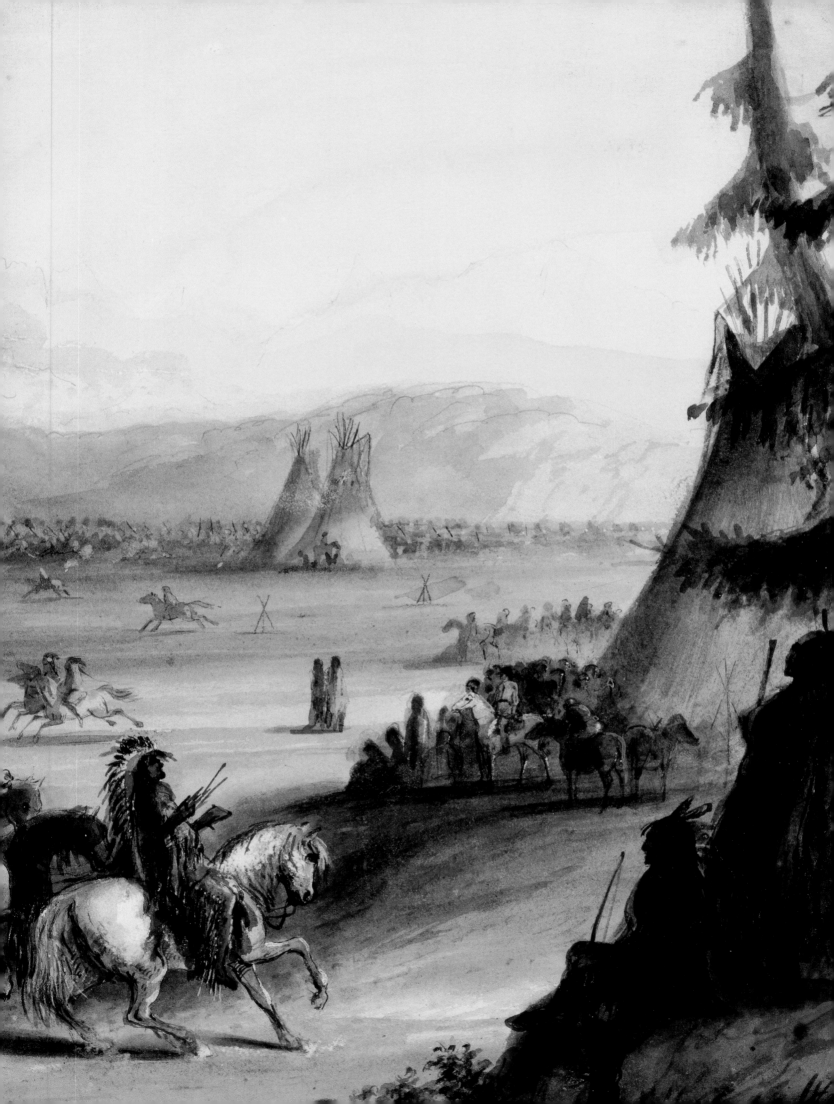

(Each work is undated unless otherwise noted.)

ALFRED T. AGATE (1812–1846), AMERICAN
1. *Fort Umqua, Oregon,* watercolor on paper, 11¼ × 8½ in. (0236.698)

2. *Hood Mountain* [Oregon], watercolor on paper, 11¼ × 8½ in. (0236.703)

JOHN JAMES AUDUBON (1785–1851), AMERICAN, BORN SANTO DOMINGO (NOW HAITI)
3. *Pair of Cooper's Hawk,* oil on canvas, 39 × 26 in. (0126.2321); **pl. 25**

JOHN WOODHOUSE AUDUBON (1812–1862), AMERICAN
4. *Black Beaver (Delaware Chief),* oil on canvas, 22 × 28 in. (0126.1565); **pl. 26**

JOSEPH BECKER (1841–1910), AMERICAN
5. *Snow Sheds on the Central Pacific Railroad in the Sierra Nevada Mountains,* oil on canvas, 19 × 26 in. (0136.1212); **pl. 54**

ALBERT BIERSTADT (1830–1902), AMERICAN, BORN GERMANY
6. *Black Hills, Colorado,* c. 1876, oil on paper, 13⅛ × 19⅛ in. (0136.28)

7. *Buffalo Hunt or Last of the Buffalo,* 1891, photogravure, 16½ × 27½ in. (1526.167)

8. *Canoes,* oil on paper, 13 × 18¼ in. (0126.1176)

9. *In the Sierra Nevada Mountains,* oil on canvas, 18 × 24 in. (0126.1180)

10. *Multnomah Falls* [Oregon], oil on canvas, 44¼ × 30⅜ in. (0126.2354); **pl. 62**

11. *Wind River Mountains, Rocky Mountain Chain,* 1859, oil on paper, 10¾ × 13 in. (0136.21)

KARL BODMER (1809–1893), SWISS
12. *Interior of the Hut of a Mandan Chief,* ink, wash, and gouache on paper, 11 × 16 in. (0276.1742); **pl. 39**

The following prints are after Karl Bodmer, from *Travels in the Interior of North America,* 1844:

13. "Bison Dance of the Mandan Indians in Front of Their Medicine Lodge," 1844, hand-colored aquatint, mezzotint, and etching on paper, 16½ × 21⁵⁄₁₆ in. (4576.91.52B)

14. "Fort Union on the Missouri," 1844, hand-colored aquatint, etching, engraving, and roulette on paper, 13¹¹⁄₁₆ × 17¹⁄₁₆ in. (4576.91.62B)

15. "Herds of Bisons and Elks on the Upper Missouri," 1844, hand-colored aquatint and etching on paper, 14¼ × 16⅝ in. (4576.91.80B)

16. "Junction of the Yellow Stone River with the Missouri," 1844, hand-colored aquatint, etching, and roulette on paper, 16¹⁄₁₆ × 21⁷⁄₁₆ in. (4576.91.63B)

17. "Mássika, Saki [Sauk] Indian, and Wakusásse, Musquake [Fox] Indian," 1844, hand-colored aquatint, etching, mezzotint and stipple on paper, 15⅞ × 19⅜ in. (plate mark) (4576.91.37B); **pl. 17**

CHECKLIST OF THE EXHIBITION

18. "Mato Tope, a Mandan Chief," 1844, hand-colored aquatint, etching, stipple, and roulette on paper, 20 × 14½ in. (4576.91.47B)

19. "Mih Tutta Hangkusch, a Mandan Village," 1844, hand-colored aquatint, etching, and roulette on paper, 13½ × 16½ in. (4576.91.50B)

20. "Pehriska Ruhpa, a Minatarre or Big-bellied Indian," 1844, hand-colored aquatint, etching, roulette, stipple, and mezzotint on paper, 20¼ × 14½ in. (4576.91.51B)

21. "Sih-Chida [Yellow Feather] & Mahchsi-Karehde [Flying War Eagle] / Mandan Indians," 1844, hand-colored aquatint, etching, engraving, and mezzotint on paper, 19¹³⁄₁₆ × 16½ in. (4576.91.62B)

22. "The Travellers Meeting with the Minatarre Indians near Fort Clark," 1844, hand-colored aquatint, etching, and roulette on paper, 11 × 13½ in. (4576.91.27B)

JOHN ROSS BROWNE (1821–1875), AMERICAN, BORN IRELAND
23. *Chinese Mining Camp,* ink wash on paper, 11 × 14¾ in. (0236.723); **pl. 27**

24. *New Furnices [Furnaces],* ink wash on paper, 13¼ × 15⅞ in. (0236.722); **pl. 28**

GEORGE CATLIN (1796–1872), AMERICAN
25. *Ee-hee-a-duck-chee-a, He Who Ties His Hair Before* [Crow], 1836, watercolor on paper, 10¾ × 8¼ in. (0226.1548); **pl. 16**

26. *His-oo-san-chees, the Little Spaniard,* 1836, watercolor on paper, 10 × 8⅛ in. (0226.1534)

27. *Mah-to-toh-pa, the Four Bears,* 1836, watercolor on paper, 10¼ × 8½ in. (0226.1543)

28. *Men-són-se-ah, the Left Hand, Piankashaw,* 1830, watercolor on paper, 6 × 4⅞ in. (0226.1500); **pl. 14**

29. *A Pawnee Pict Wigwam and Family in Western Texas* [Western Oklahoma], 1852, oil on canvas, 11⅛ × 14⅝ in. (0176.2161); **pl. 41**

30. *Red Jacket* [Sa-go-ye-wat-ha, Seneca], 1827, watercolor on mounted paper, 11¼ × 7½ in. (0226.1566); **pl. 13**

31. *Several Families of Sioux Indians Encamped, Killing Buffaloes and Drying Meat and Dressing the Skins for Robes,* 1852, oil on canvas, 11¼ × 14½ in. (0176.2136)

32. *Village of the Pawnee Picts at the Base of the Rocky Mountains, Western Texas* [Wichita Village in Indian Territory at the Base of the Wichita Mountains], 1852, oil on canvas, 11⅛ × 14⅝ in. (0176.2124); **pl. 40**

33. *Wah-ro-née-sah, the Surrounder, Oto Chief,* 1832, watercolor on paper, 5¾ × 5¼ in., (0226.1542); **pl. 15**

ALONZO CHAPPEL (1828–1887), AMERICAN
34. *The Fate of Jane Wells,* 1856, oil on canvas, 27 × 22 in. (0126.1651); **pl. 56**

FREDERIC EDWIN CHURCH (1826–1900), AMERICAN
35. *Gold Mining in California,* watercolor on paper, 12½ × 18 in. (0236.1438)

36. *Sacramento River Looking East to Mt. Shasta on the Left, Lesser Peak on the Right,* watercolor on paper, 12½ × 18½ in. (0236.1437)

VINCENT COLYER (1825–1888), AMERICAN
37. *Camp Prescott, General Crook's Camp, Arizona in 1871,* watercolor on paper, 3½ × 9¾ in. (0236.1381)

38. *Col. Green's Headquarters, White Mountain Reservation, Arizona, in 1871,* watercolor on paper, 6¾ × 9¾ in. (0236.1380)

39. *Ferry Crossing Arkansas River in 1867,* watercolor on paper, 6 × 9½ in. (0236.1375)

40. *Wichita Agency, Indian Territory* [Oklahoma] *in 1869,* watercolor on paper, 5¾ × 9½ in. (0236.1376)

FELIX O. C. DARLEY (1822–1888), AMERICAN
41. *Indian Brave,* black and white wash on paper, 10¼ × 7¼ in. (0226.1445)

CHARLES DEAS (1818–1867), AMERICAN
42. *Pawnees on the Trail of an Enemy,* c. 1844, oil on canvas, 15 × 11½ in. (0126.1169)

JOSEPH DRAYTON (1795–1856), AMERICAN
43. *Shasta Mountain* [California], watercolor on paper, 11¼ × 8½ in. (0236.699)

44. *Umqua River* [Oregon], watercolor on paper, 11¼ × 8½ in. (0236.701)

SETH EASTMAN (1808–1875), AMERICAN
45. *Buffalo Chase,* watercolor on paper, 5½ × 8¾ in. (0226.1385)

46. *Combat Between the Ojibways and the Sacs and Foxes on Lake Superior,* watercolor on paper, 6 × 9½ in. (0226.1382)

47. *Maiden Rock,* oil on canvas, 17 × 25 in. (0126.1124); **pl. 24**

48. *Sioux Indian Council,* 1848, watercolor on paper, 6 × 8½ in. (0226.1384)

49. *Sioux Indians Playing Lacrosse,* 1848, watercolor on paper, 5¼ × 8¼ in. (0226.1383)

50. After Seth Eastman, "Ball Play on the Prairie," engraving, 9¼ × 12 in., in Henry R. Schoolcraft, *Information Respecting the History, Condition, and Prospects of the Indian Tribes of the United States,* part 2, 1852 (3736.305); **pl. 52**

51. After Seth Eastman, "Medicine-Dance of the Winnebagoes," engraving, 6 × 9⅛ in., in Mary Eastman, *The American Aboriginal Portfolio,* 1852 (2126.1798); **pl. 51**

ALVAN FISHER (1792–1863), AMERICAN
52. *The Escape of Major McCulloch,* c. 1840s, oil on canvas, 36 × 42 in. (0162.1160); **pl. 60**

GEORGE HARVEY (1800–1878), AMERICAN
53. *The Committee on the International Telegraph in Paris,* 1867, oil on canvas, 16 × 21 in. (0176.1214); **pl. 53**

EASTMAN JOHNSON (1824–1906), AMERICAN
54. *Indian Mother,* oil on canvas, 16¾ × 13½ in. (0126.1507); **pl. 47**

55. *Portrait of an Indian Family,* oil on canvas, 23½ × 23½ in. (0126.1506); **pl. 48**

PAUL KANE (1810–1871), CANADIAN, BORN IRELAND
56. *Sault Saint Marie—American Side* [Michigan], 1846, oil on canvas, 18 × 30 in. (0116.1158); **pl. 42**

57. *White Mud Portage, Winnipeg River,* c. 1848, oil on canvas, 18 × 30 in. (0116.1157)

CHARLES BIRD KING (1785–1862), AMERICAN
58. *Big Elk, or Great Orator, Omahaw Chief,* oil on wood, 17 × 14 in. (0126.1201)

59. *David Vann* [Cherokee], c. 1852, oil on wood panel, 18 × 14½ in. (0126.1193); **pl. 12**

60. After Charles Bird King, "Wa-pel-la, Chief of the Musquakees [Fox]," 1837, hand-colored lithograph, 20 × 13¾ in. (sheet size), in Thomas L. McKenney and James Hall, *History of the Indian Tribes of North America*, 1842 (2126.1815); **pl. 11**

CORNELIUS D. KRIEGHOFF (1815–1872), CANADIAN, BORN HOLLAND
61. *Winter Duties*, 1860, oil on canvas, 14 × 22 in. (0136.1153)

RUDOLPH F. KURZ (1818–1871), SWISS
62. *Departing from Fort Berthold* [North Dakota], watercolor on paper, 15 × 20⅜ in. (0226.1351)
63. *Indians and Horses Crossing a River*, watercolor on paper, 9¾ × 12⅞ in. (0226.1344); **pl. 49**
64. *Spring Camp of the Indians*, watercolor on paper, 12⅞ × 7½ in. (0226.1352)

EMANUEL LEUTZE (1816–1868), AMERICAN, BORN GERMANY
65. *Indians and Captive*, oil on canvas, 16 × 24½ in. (0126.1614); **pl. 59**
66. *Westward the Course of Empire Takes Its Way*, c. 1861, oil on canvas, 30 × 40 in. (0126.1615); **pl. 55**

AFTER JAMES OTTO LEWIS (1799–1858), AMERICAN
67. "Kee-o-kuck or the Watching Fox, the present Chief of the Sauk tribe and Successor to Black Hawk," hand-colored lithograph, 19 × 11 in. (sheet size), in *Aboriginal Port Folio*, 1835 (2126.1769); **pl. 10**

ALFRED JACOB MILLER (1810–1874), AMERICAN
68. *Buffalo Hunt*, 1840, oil on canvas, 30 × 44 in. (0126.739); **pl. 21**
69. *Fort Laramie*, 1851, oil on canvas, 18 × 27 in. (0126.727); **pl. 29**
70. *Indian of the Snake* [Shoshone] *Tribe*, watercolor on paper, 10¼ × 8¼ in. (0226.1052); **pl. 19**
71. *Indian Procession in Honor of Captain W. D. Stewart near the Rocky Mountains*, watercolor on paper, 10 × 15 in. (0236.1092); **pl. 36**
72. *Indians on Green River*, oil on canvas, 21½ × 36 in. (0126.732); **pl. 20**

73. *Interior of Fort Laramie*, c. 1837, watercolor on paper, 10⅝ × 14⅛ in. (0226.1067); **pl. 30**
74. *Kaw* [Kansa] *Indian*, watercolor on paper, 11 × 8¼ in. (0226.1037); **pl. 18**
75. *Lassoing Wild Horses*, oil on canvas, 27 × 34 in. (0126.740); **pl. 22**
76. *Sioux Camp Scene*, oil on canvas, 14 × 20 in. (0126.725)
77. *Sir William Drummond Stewart Meeting Indian Chief*, oil on canvas, 33 × 42½ in. (0126.738); **pl. 31**
78. *A Snake Indian Giving a Description of a Party Who Have Previously Passed by Trails Left on the Ground*, watercolor on paper, 11 × 9⅛ in. (0236.1072); **pl. 33**
79. *The Thirsty Trapper*, oil on paper, 9⅛ × 8 in. (0136.743); **pl. 32**
80. *Threatened Attack on the Caravan by a Horde of Indians*, oil on paper, 9 × 14¼ in. (0136.2429); **pl. 35**
81. *Trappers Threatened by Indians*, watercolor on paper, 9⁹⁄₁₆ × 12⅞ in. (0236.1094); **pl. 34**

THOMAS MORAN (1837–1926), AMERICAN, BORN ENGLAND
82. *The Cliffs of Green River, Wyoming*, 1879, graphite, watercolor, and white gouache on paper, 9¾ × 23 in. (0236.930)
83. *First Sketch Made in the West at Green River, Wyoming*, 1871, graphite, watercolor, and white gouache on paper, 3¾ × 8⅛ in. (0236.882)
84. *The Glory of the Canyon*, 1875, oil on canvas, 52 × 38½ in. (0126.2350); **pl. 4**
85. *The Guard*, oil on panel, 12⅜ × 7⁵⁄₁₆ in. (0126.1107)
86. *In the Narrows, Zion Valley, the Gate Keeper* [Utah], 1873, graphite, watercolor, and white gouache on paper, 9¾ × 6⅜ in. (0236.878)
87. *Side Canyon of the Colorado* [River, Grand Canyon, Arizona], 1878, oil on canvas, 44¾ × 38¾ in. (0126.2345); **pl. 63**
88. *The Three Tetons*, 1881, oil on panel, 14 × 20 in. (0126.2349)

CHARLES C. NAHL (1818–1878), AMERICAN, BORN GERMANY
89. *Treaty with the Shoshone Indians in 1866*, oil on canvas, 27 × 37 in. (0136.1481); **pl. 5**

AFTER CARL NEBEL (1805–1855), GERMAN
90. "General Scott's Entrance into Mexico," hand-colored lithograph, 11⅛ × 17 in., in George Wilkins Kendall, *The War between the United States and Mexico*, 1851 (2526.3008); **pl. 7**

JOHANNES SIMON OERTEL (1823–1909), AMERICAN, BORN GERMANY
91. *The Marauders*, 1860, oil on canvas, 16 × 20 in. (0126.1640); **pl. 57**

AFTER TITIAN RAMSAY PEALE (1799–1885), AMERICAN
92. "Moveable Skin Lodges of the Kaskaias," 1823, engraving, 6¾ × 8¾ in., in Edwin James, *Account of an Expedition from Pittsburgh to the Rocky Mountains Performed in the Years 1819 and 1820, by Order of the Honorable J. C. Calhoun, Secretary of War, under the Command of Major Stephen H. Long*, atlas vol. (2426.228); **pl. 3**

WILLIAM TYLEE RANNEY (1813–1857), AMERICAN
93. *The Old Scout's Tale*, c. 1853, oil on canvas, 13½ × 19½ in. (0126.2261)

PETER RINDISBACHER (1806–1834), AMERICAN, BORN SWITZERLAND
94. *Canadian* [Cree] *Indians and Artist*, watercolor on paper, 8 × 7 in. (0226.1341); **pl. 38**
95. *In the Teepee*, pen, ink, and watercolor on paper, 7⅛ × 9 in. (0226.1342); **pl. 37**

CHARLES B. J. F. DE SAINT-MÉMIN (1770–1852), FRENCH
96. *Mandan King* [Shahaka, Mandan Chief], 1807, watercolor on paper, 6¾ × 6 in. (0226.1369); **pl. 8**
97. *Mandan Queen* [Yellow Corn, Wife of Shahaka], 1807, watercolor on paper, 6¾ × 6 in. (0226.1370); **pl. 9**

AFTER SAMUEL SEYMOUR (1775–c. 1823), AMERICAN, BORN ENGLAND
98. "View of the Rocky Mountains on the Platte 50 miles from their Base," 1823, engraving, 6 × 8¾ in., in Edwin James, *Account of an Expedition from Pittsburgh to the Rocky Mountains . . .*, atlas vol. (2426.228); **pl. 2**

99. "War Dance [Dog Dance] in the Interior of a Konza [Kansa] Lodge," 1823, engraving, 6⅜ × 8¾ in., in Edwin James, *Account of an Expedition from Pittsburgh to the Rocky Mountains . . . ,* atlas vol. (2426.228); **pl. 1**

JOHN MIX STANLEY (1814–1872), AMERICAN
100. *Game of Chance,* 1853, oil on canvas, 27½ × 38⅝ in. (0126.1137); **pl. 46**

101. *Tepia Gatherers,* c. 1853, oil on canvas, 21 × 30½ in. (0126.1142); **pl. 45**

ATTRIBUTED TO ALEXANDER STUART (1831–1898), AMERICAN, BORN SCOTLAND
102. *The Attack of the Merrimack on Union Naval Vessels,* oil on canvas, 30 × 50 in. (0116.1559); **pl. 61**

ALFRED SULLY (1821–1879), AMERICAN
103. *Fort Kearney* [Nebraska], 1860, watercolor on paper, 9⅜ × 13 in. (0226.1335)

104. *Fort Snelling* [Minnesota], 1855, watercolor on paper, 7⅝ × 11⅜ in. (0226.1331)

105. *Fort Snelling* [Minnesota], 1855, watercolor on paper, 8⅜ × 11⅝ in. (0226.1336)

106. *Indian Maidens,* oil on canvas, 17 × 22½ in. (0126.1100); **pl. 44**

107. *Indian Spearing Salmon,* oil on canvas, 15⅛ × 20⅛ in. (0126.1101); **pl. 43**

108. *Inside of Fort Pierre, Nebraska Territory,* 1856, watercolor on paper, 8⅜ × 11⅝ in. (0226.1332)

ARTHUR F. TAIT (1819–1905), AMERICAN, BORN ENGLAND
109. *The Check,* 1854, oil on canvas, 30 × 44 in. (0126.1159); **pl. 58**

110. After Arthur F. Tait, *The Pursuit,* 1856, hand-colored lithograph on paper, published by Currier and Ives, 17¾ × 25½ in. (1526.559)

JAMES WALKER (1819–1889), AMERICAN, BORN ENGLAND
111. *The Battle of Buena Vista* [Mexico], oil on canvas, 23½ × 38½ in. (0126.1633); **pl. 6**

AFTER HENRY J. WARRE (1819–1898), ENGLISH
112. "Fort Vancouver," hand-colored lithograph, 7½ × 11⅝ in., in *Sketches in North America and the Oregon Territory,* 1848 (2176.1014)

113. "Indian Tomb," hand-colored lithograph, 7½ × 11⅝ in., in *Sketches in North America and the Oregon Territory,* 1848 (2176.1014); **pl. 50**

WESLEY WEBBER (1839–1914), AMERICAN
114. *Locomotive in Snow,* oil on canvas, 16 × 22¼ in. (0126.1209)

CARL WIMAR (1828–1862), AMERICAN, BORN GERMANY
115. *Indian Encampment on the Big Bend of the Missouri River,* 1860, oil on canvas, 25 × 49 in. (0126.1598); **pl. 23**

Anderson, Nancy K., and Linda S. Ferber. *Albert Bierstadt: Art and Enterprise*. New York: Hudson Hills Press in association with the Brooklyn Museum, 1990.

Anderson, Nancy K., et al. *Thomas Moran*. Washington, D.C.: National Gallery of Art; New Haven: Yale University Press, 1997.

Audubon, John James, and Rev. John Bachman. *The Viviparous Quadrupeds of North America*. 3 vols. New York: J.J. Audubon, 1846, 1851, 1856.

Barber, John W., and Henry Howe. *Historical Collections of the State of New York*. New York: S. Tuttle Publishers, 1841.

Baur, John I. H. *An American Genre Painter: Eastman Johnson, 1824–1906*. Brooklyn: Brooklyn Museum, 1940.

Boatner, Mark M., III. *The Encyclopedia of the American Revolution*. New York: D. McKay, 1966.

Bryant, Edwin. *What I Saw in California*. New York: D. Appleton, 1848.

Butler, Steven R., ed. *A Documentary History of the Mexican War*. Richardson, Tex.: Descendants of Mexican War Veterans, 1995.

Catlin, George. *North American Indians: Being Letters and Notes on Their Manners, Customs, and Conditions, Written during Eight Years' Travel amongst the Wildest Tribes of Indians in North America, 1832–1839*. 2 vols. Edinburgh: John Grant, 1926.

Eastman, Mary Henderson. *Dahcotah; or, Life and Legends of the Sioux around Fort Snelling*. Preface by Rena Neumann Coen. Afton, Minn.: Afton Historical Society Press, 1995.

———. *The American Aboriginal Portfolio*. Philadelphia: Lippincott, Grambo, 1853.

Ewers, John C. *Artists of the Old West*. New York: Doubleday, 1965.

Fineman, Charles. *Art and Artists of the Capitol of the United States of America*. Washington, D.C.: U.S. Government Printing Office, 1927.

Gilbert, Bill. *The Old West: The Trailblazers*. New York: Time-Life Books, 1973.

Goetzmann, William H., and William N. Goetzmann. *The West of the Imagination*. New York: W.W. Norton, 1986.

Goetzmann, William H., David C. Hunt, Marsha V. Gallagher, and William J. Orr. *Karl Bodmer's America*. Lincoln: Joslyn Art Museum and University of Nebraska Press, 1984.

Goetzmann, William H., and Glyndar Williams. *The Atlas of North American Exploration: From the Norse Voyages to the Race to the Pole*. Norman: University of Oklahoma Press, 1992.

Gold Thwaites, Reuben, ed. *Original Journals of the Lewis and Clark Expedition, 1804–1806*. New York: Dodd, Mead, 1904.

Horan, James D. *The McKenney-Hall Portrait Gallery of American Indians*. New York: Crown Publishers, 1872.

"Icons: Faces of Heros." *Gilcrease Journal* 8, no. 1 (2001).

Idaho State Historical Society Reference Series, http://www.idahohistory.net/ reference_series.html (numbers 369 and 370).

BIBLIOGRAPHY

James, Edwin. *Account of an Expedition from Pittsburgh to the Rocky Mountains Performed in the Years 1819 and 1820, by Order of the Honorable J. C. Calhoun, Secretary of War, under the Command of Major Stephen H. Long.* Philadelphia: H. C. Carey and I. Lea, 1823.

Jefferson, Thomas. Papers Series 1, Library of Congress. Accessed at "They Helped to Fill Up the 'Canvas,'" The Loc.gov Wise Guide, http://www.loc.gov/wiseguide/oct03/lewisclark.html

Johnston, Patricia Condon. *Eastman Johnson's Lake Superior Indians.* Afton, Minn.: Johnston Publishing, 1983.

Josephy, Alvin M., Jr. *The Artist Was a Young Man: The Life Story of Peter Rindisbacher.* Fort Worth: Amon Carter Museum, 1970.

Kane, Paul. *Paul Kane's Frontier: Including Wanderings of an Artist Among the Indians of North America.* Edited with an introduction and catalogue raisonné by J. Russell Harper. Austin: University of Texas Press, 1971.

Kloss, William, and Diane K. Skvarla. *United States Senate Catalogue of Fine Art.* Washington, D.C.: U.S. Government Printing Office, 2002.

Kurz, Rudolph Friederich. *Journals of Rudolph Friederich Kurz: An Account of His Experiences Among the Fur Traders and American Indians on the Mississippi and the Upper Missouri Rivers During the Years 1846 to 1852.* Translated by Myrtis Jarrell, edited by J. N. B. Hewitt. Washington, D.C.: U.S. Government Printing Office, 1937.

Lewis, James Otto. *Aboriginal Port Folio.* Philadelphia: James Otto Lewis, 1835–1836.

McKenney, Thomas L., and James Hall. *History of the Indian Tribes of North America, with Biographical Sketches and Anecdotes of the Principal Chiefs, Embellished with One Hundred and Twenty Portraits from the Indian Gallery in the Department of War at Washington.* 3 vols. Philadelphia: Daniel Rice & James G. Clark, 1842–1844, folio 1837–1844.

McLuhan, T.C. *Touch the Earth: A Self-Portrait of Indian Existence.* New York: Promontory Press, reprinted by arrangement with Outerbridge & Dienstfrey, 1992.

Miles, Ellen G. *Saint-Mémin and the Neoclassical Profile Portrait in America.* Washington, D.C.: National Portrait Gallery, Smithsonian Institution Press, 1994.

Moran, Thomas. Papers. Gilcrease Museum, Tulsa.

Myers, Fred, et al. *Thomas Gilcrease and His National Treasure.* Tulsa: Gilcrease Museum, 1987.

Pike, Zebulon. *An Account of Expedition to the Sources of the Mississippi and Through Western Parts of Louisiana . . . during the Years 1805, 1806, and 1807; and a Tour Through the Interior Parts of New Spain.* Philadelphia: C. & A. Conrad, 1810.

Potter, Tracy. *Sheheke, Mandan Indian Diplomat: The Story of White Coyote, Thomas Jefferson, and Lewis and Clark.* Helena, Mont.: Farcountry Press, 2003.

Rhodes, Richard. *John James Audubon: The Making of an American.* New York: Alfred A. Knopf, 2004.

Rock, Francis John. *J. Ross Browne: A Biography.* Washington, D.C.: Catholic University of America, 1929.

Ross, Marvin C. *The West of Alfred Jacob Miller (1837) from the Notes and Water Colors in the Walters Art Gallery.* Norman: University of Oklahoma Press, 1951.

Rossi, Paul A., and David C. Hunt. *The Art of the Old West.* New York: Alfred A. Knopf, 1971.

Samuels, Peggy, and Harold Samuels. *The Illustrated Biographical Encyclopedia of Artists of the American West.* Garden City, N.Y.: Doubleday, 1976.

Schoolcraft, Henry Rowe. *Information Respecting the History, Condition, and Prospects of the Indian Tribes of the United States: Collected and Prepared Under the Direction of the Bureau of Indian Affairs, per Act of Congress of March 3rd, 1847.* 6 vols. Philadelphia: Lippincott, Grambo, 1851–1857.

———. *Personal Memoirs of a Residence of Thirty Years with the Indian Tribes on the American Frontiers.* New York: AMS Press, 1978.

Sheldon, G. W. *American Painters.* New York: D. Appleton, 1879.

"The Sioux Chief." *The Casket: Flowers of Literature, Wit and Sentiment for 1829.* Philadelphia: Samuel C. Atkinson, 1829.

Stanley, John Mix. *Portraits of North American Indians, with Sketches of Scenery, etc., Painted by J.M. Stanley, Deposited with the Smithsonian Institution.* Washington, D.C.: Smithsonian Institution, 1852.

Stegner, Page. *Winning the Wild West: The Epic Saga of the American Frontier, 1800–1899.* New York: Free Press, 2002.

Sully, Langdon. *No Tears for the General: The Life of Alfred Sully, 1821–1879.* Palo Alto, Calif.: American West Publishing Company, 1974.

Taft, Robert. *Artists and Illustrators of the Old West: 1850–1900.* New York: Charles Scribner, 1953.

Truettner, William H. *The Natural Man Observed: A Study of Catlin's Indian Gallery.* Washington, D.C.: Smithsonian Institution, 1979.

Tyler, Ron. *Audubon's Great National Work: The Royal Octavo Edition of "Birds of America."* Austin: University of Texas Press, 1993.

———. *Prints of the West: Prints from the Library of Congress.* Golden, Colo.: Fulcrum Publishing, 1994.

———, ed. *Alfred Jacob Miller: Artist on the Oregon Trail.* With a catalogue raisonné by Karen Dewees Reynolds and William R. Johnston. Fort Worth: Amon Carter Museum, 1982.

Utley, Robert M., ed. *The Story of the West: A History of the American West and Its People.* New York: DK Publishing, 2003.

Viola, Herman J. *Thomas L. McKenney: Architect of America's Early Indian Policy, 1816–1830.* Chicago: Swallow Press, 1974.

Ward, Christopher. *The War of the Revolution.* Edited by John Richard Alden. New York: MacMillan, 1952.

Warre, Henry James. *Sketches in North America and the Oregon Country.* London: Dickenson, 1848.

INDEX

Art titles in quotes refer to reproductions of artist's original artwork.
Boldface page references refer to illustrations, and page references
located after names refer to discussion.